The Cartoonist

The Cartoonist

Betsy Byars

PUFFIN BOOKS

PUFFIN BOOKS

Published by the Penguin Group

Penguin Books USA Inc., 375 Hudson Street, New York, New York 10014, U.S.A.
Penguin Books Ltd, 27 Wrights Lane, London W8 5TZ, England
Penguin Books Australia Ltd, Ringwood, Victoria, Australia
Penguin Books Canada Ltd, 10 Alcorn Avenue, Toronto, Ontario, Canada M4V 3B2
Penguin Books (N.Z.) Ltd, 182-190 Wairau Road, Auckland 10, New Zealand

Penguin Books Ltd, Registered Offices: Harmondsworth, Middlesex, England

First published in the United States of America by
Viking Children's Books, a division of Penguin Books USA Inc., 1978
First published in Puffin Books, 1987

14 16 18 20 19 17 15 13

The Library of Congress Cataloging-in-Publication Data:
Byars, Betsy Cromer. The cartoonist.
Summary: Threatened with the loss of his private place in the attic of his
crowded home, a young boy determines to keep it at all costs.
[1. Family life—Fiction.] I. Title
[PZ7.B9836Car 1987] [Fic] 87-16920 ISBN 0-14-032309-0

Printed in the U.S.A.

For Amy Laura

Chapter One

"Alfie?"

"What?"

"You studying?"

"Yes," he lied.

"Well, why don't you come down and study in front of the television? It'll take your mind off what you're doing," his mother called.

He didn't answer. He bent over the sheet of paper on his table. He was intent.

"Did you hear me, Alfie?"

"I heard," he called without glancing up.

"Well, come on down." She turned and spoke to Alma. "Who's the announcer that says that on TV? It's some game show. He says, 'Come on downnnn,' and people come running down the aisle to guess the prices."

"I don't know, Mom. I don't watch that junk," Alma said.

1

"But you know who I'm talking about. Alfie Mason, come on downnnnn!"

Alfie didn't answer. He was drawing a comic strip called "Super Bird."

In the first square a man was scattering bird-seed from a bag labeled "Little Bird Seed." In the next square little birds were gobbling up the seeds.

In the third square the man was scattering bird-seed from a bag labeled "Big Bird Seed." In the next square big birds were gobbling up the seeds.

In the fifth square the man was scattering huge lumps from a bag labeled "Giant Bird Seed." In the last square a giant bird was gobbling up the little man.

There was a smile on Alfie's face as he looked at what he had done. At the top of the drawing he lettered in the words *Super Bird*. He was going to do twelve of these super comic strips, he had decided, one for each month. When he got through, he would call it "Super Calendar." Maybe he would get it published, and later, when he learned how, he would animate "Super Bird," make it into a film. Whenever he drew something, he always saw it in motion.

"Alfie?" his mom called again.

"I'm busy, Mom. I'm studying."

"Well, supper's ready."

"Oh."

"Come down right now."

"I am. I just want to get my papers in order. If I leave them in a mess, sometimes I can't . . ." He trailed off.

He now had two strips for his calendar. "Super Bird" and "Super Caterpillar." He didn't know which he liked best. He looked from one to the other, comparing them.

In the first square of "Super Caterpillar," a giant caterpillar was happily eating New York City. In the second square he was happily eating New York State. In the third he was happily eating the world. In the last square, he was unhappily falling through space, his stomach a big round ball. Alfie was especially pleased with the expression in Super Caterpillar's eyes as he tumbled helplessly through space.

"Alfie!" his mother called loudly. Alfie knew she was at the foot of the ladder now. She rattled the ladder as if she were trying to shake him down. "I'm coming up there and pull you down by the ear if you don't come this minute."

"I'm *coming.*"

He got up quickly and turned his papers face down on the table. He started for the ladder that led downstairs.

Coming down from the attic was like getting off one of those rides at the amusement park, Alfie

thought. It left him feeling strange, as if he had moved not from one part of the house to another but from one experience to another without time to get his balance.

Alfie and his family had been living in this house for seven months, and when Alfie had first seen it he had thought of that old rhyme about the crooked man who lived in a crooked house. Nothing about this house was straight. It had started as two rooms, and then another room had been added. A kitchen had been made from the back porch. The roof was three different colors. The doors were crooked and so were the windows. The floors slanted. If you set a ball on the floor, it would roll to the wall. The house had been built by three different men, none of whom had ever had a lesson in carpentry.

The only thing Alfie liked about the house was the attic. That was his. He had put an old chair and a card table up there, and he had a lamp with an extension cord that went down into the living room. Nobody ever went up but Alfie. Once his sister, Alma, had started up the ladder, but he had said, "No, I don't want anybody up there."

She'd paused on the ladder. "Why not?"

"Because . . ." He had hesitated, trying to find words to express his meaning. "Because," he said finally, "I want it to be *mine*."

Alma had nodded. She understood how important it was to have things of your own because their mother used everything of Alma's from her cosmetics to her shoes.

Now Alfie closed the trap door, easing it down because it was heavy. He climbed down into the living room.

"I don't know what you do up there," his mom said, watching him.

"I study."

"Well, it's not healthy—no windows, no air. I keep expecting you to smother. Mr. Wilkins has an old window in his garage. Maybe I could get him to—"

"I like it just the way it is," Alfie said quickly.

"Well, you ought to be more like Bubba," she said, eyeing him critically. "When he was your age he was outside every day, passing a football, dribbling a basketball—"

"Stealing a baseball," Alma added.

His mother ignored Alma. "You're never going to be on a team."

"That's true," he said.

"But, Alfie, everybody wants to be on a team!" She broke off, then said tiredly, "Now, where's Pap? Get him, Alfie. Tell him supper's ready but don't tell him it's Sloppy Joes or he won't come."

Alfie went out the back door. He knew his

grandfather would be sitting in the yard, reading yesterday's newspaper.

"Supper's ready," he said to his grandfather's back.

His grandfather was hunched over the paper, muttering to himself as he read. "Look at that, will you?"

Alfie knew he wasn't expected to look, just listen. He leaned against the side of the door. "What's happened?" he asked.

"The President of the United States," Pap said, his voice heavy with disgust, "has given away twenty million bushels of grain to the Russians."

"He didn't *give* it to them, Pap?"

"As good as. And you know who's going to pay, don't you?" He looked around, his heavy brows drawn low over his eyes. Then his brows jumped up as if they were on strings. "You and me."

"Yeah," Alfie said.

His grandfather turned back to the newspaper, looking for something else that would irritate him. "Ha," he said, finding something. He circled the important articles with a yellow Magic Marker. "Listen here. The state highway department is going busted. They're going to be six million dollars in debt by the end of the year if the state senate don't bail them out."

"Pap, supper's ready," he said quietly.

6

"And you know who's *really* going to bail them out, don't you?"

"You and me."

"Yeah, you and me who don't even own a car." He snapped the newspaper back into place. "I built me a car when I wasn't much older than you. Did I ever tell you about it?"

"Yes."

"Stole all the parts. It never cost me a cent."

"It wouldn't run, though."

"I had one ride in it. Best car ride I ever had. My brothers pushed me down the road in it, see, hoping it would start up when it got rolling. We lived at the top of a steep hill in those days, and it got rolling, all right. Oh, did it roll!"

"It didn't start, though."

Pap ignored him. "Wind was whipping back my hair—I didn't put no windshield in the car—I can still feel it. And my brothers was yelling and hanging on—they jumped on soon as I got going—my brother Alvin was lying on the hood—and I was steering. I felt as good as if I was at the Indy 500. That was some ride." His grandfather sat staring into space, remembering.

"Are you two coming to supper or not?" his mother said. She was standing just inside the screen door.

"We're coming," Alfie said. "Come on, Pap."

7

Slowly his grandfather got to his feet. "You steal me enough parts and I'll make you a car. I can do it. We could coast down the hill on it anyways. It would be something to do."

"I don't want to make a car."

"If you'd been on that ride with me, you'd want to."

"Maybe."

"I didn't want to do nothing else for the longest time. When you find something you like to do, well, then you want to keep on doing it."

Alfie thought of his drawings upstairs. "That's true," he said.

"I wish we still had the wrecking business," Pap said sorrowfully. "Maybe you and me can get it going again—just one or two good wrecked cars and we—"

"He's going to be a football player," his mom said behind them.

The three of them stood without moving for a moment. Alfie looked down at his feet. His feet turned in. When he was just beginning to walk, a neighbor had told his mother that if she put his shoes on the wrong feet, his feet would turn out. His earliest memories were of women stopping his mother in the A&P and saying, "Did you know your little boy's got his shoes on the wrong feet?" He used to stand with his legs crossed so that his

8

shoes would look like everybody else's.

Now he tried to imagine his turned-in feet in football shoes, waiting on AstroTurf for the kickoff. He glanced back at his mom. She had a pleasant look on her face. She was in the bleachers again, cheering for Alfie as she had once cheered for Bubba. She was wearing her good-luck pants suit and holding her good-luck monkey's paw. She would turn around from time to time to brag to people, "My boy's number twenty-eight, the quarterback."

"The one with the turned-in feet?" they'd ask, leaning forward over their pom-poms.

Smiling a little, Alfie glanced at his grandfather. He was still going down the hill in his make-do car with his brothers hanging off like monkeys. His face looked younger, less lined, shoved forward slightly to meet the wind.

"Well, let's eat. I got a lot of studying to do after supper," Alfie said. Studying, these days, meant drawing comic strips.

His grandfather blinked. Alfie could see he was back in the yard again—abruptly—old and disgruntled by yesterday's news. He put the paper in his chair and lumbered to the porch. As he entered the kitchen and saw the Sloppy Joes on the table, he let out a groan that seemed to come from the depths of his stomach.

"Now, Pap," Alfie's mother said soothingly, "Sloppy Joes are good for you. They build up your blood."

"Ain't no need building up an old man's blood," Pap said. He sat and shoved his paper napkin angrily in the collar of his shirt. "An old man's blood gets too strong, his veins'll give way. His veins get too strong, his skin'll give way. His skin gets too strong, his mouth'll give way—"

"I guess that's the only way we'll get any peace around here," Alfie's mother snapped. "Pass the Sloppy Joes, Alma."

Chapter Two

Alfie climbed up to the attic again after supper. His mother was hooting at a fat man on *Let's Make a Deal* who had on a gigantic baby diaper.

"And look, he's got a pacifier and everything. Come look at this fool, Alma."

"Oh, Mom, those people are disgusting."

"Pap, you want to see something funny?"

Pap didn't answer. He was making his way to the back fence, where he hoped to talk politics with his neighbor, W. C. Spivey. This was a nightly occurrence in good weather. Just after the evening news he and W. C. would meet at the back fence to curse politicians, newscasters, and the President of the United States. It was the happiest time of Pap's day.

He stopped at the back fence. "Governor!" he shouted. It was what he called Spivey. Spivey called him the Colonel. Neither title was earned. "Oh, Governor!"

Alfie pulled himself up into the attic and, as he always did, turned his head to the rafters. There were his drawings. They hung from every beam, every board. He never looked up without feeling better. No matter how low he was, looking up at his drawings always made his spirits rise.

He eased into his chair and turned over his papers. He looked at "Super Caterpillar" and "Super Bird" to see if they were as good as he remembered. He smiled. They were. He leaned "Super Bird" against a jar of pencils so he could glance at it as he worked.

He took a fresh sheet of paper and started on another super strip. He had it all planned. The idea had come to him when he had seen his mother painting her fingernails at the supper table.

He might have missed it if Alma hadn't said, "Mom, don't polish your nails at the table. This isn't a beauty parlor."

"I'm almost through." She finished the last nail and held out her hands. "How's that? It's a new shade called Tahiti Pearl."

"I *know* it's a new shade. I bought it," Alma said. She glanced at her mother critically. "And put the top back on tight." At some point, Alfie thought, Alma had become the parent; his mother, the child. Alma was the one who was stern, who never

gave in. Alma was the one who bossed him, who told him what to do.

It was the pearl nail polish that gave Alfie his idea. In the first square a girl would be painting her fingernails Pearl. In the second she would be painting her hands Pearl. In the third she would be painting her arms Pearl. In the fourth she would be painting her whole self Pearl. In the last square a giant would appear, pick her up, and set her in a tacky ring.

He would call it "Super Ring," and he knew just how the girl's face would look in that last square as she sat yoga fashion in the tacky ring.

As soon as he got the idea, he wanted to tell everybody at the table about it. He looked up. His mom was waving her fingers in the air to dry them. Pap was picking suspicious-looking things from his Sloppy Joe. Alma was reading a book beside her plate.

Alfie decided to keep this idea to himself. No one would think it funny, especially his mom. He had only made her laugh once that he could remember.

His brother, Bubba, had been able to make her laugh all the time. Everything Bubba did seemed funny to her. Alfie remembered how she had laughed the time Bubba sat Dexter Wilkins on the water fountain at school and turned on the water.

She had laughed at that until tears ran down her cheeks.

"You mean Dexter Wilkins whose dad owns Wilkins Hardware? I knew him in high school."

"Yeah, and he had on a pair of new pants."

"What kind?"

"Green double knit."

At that, his mom had leaned back on the sofa, holding her sides, laughing as if she would never stop. Even the fact that she had to go to the principal's office with Bubba the next day had not dimmed her enjoyment. In the principal's office she burst into laughter again—she had not meant to—she just couldn't help it. Every time the principal mentioned water fountain or Dexter Wilkins or green double-knit pants, she had laughed. She had tried to pretend she was coughing—she told them this when she got home—but she couldn't, and in the end the principal got disgusted and dismissed them both. Before they left the building, his mom made Bubba show her the water fountain.

Alfie ruled his paper into five squares. He drew the lines carefully because he had to save paper. A man at Logan's Printers and Binders had given him a box of old paper, and it was already half gone. Some of the sheets had printing on one side or smudges or letterheads, but Alfie had learned to use whatever he had. Before he discovered this

friend at Logan's Printers and Binders, he had gotten so desperate for paper that he had torn the front and back pages out of all his school books.

The drawing went well. In the first square the girl looked as if she were really painting her fingernails. Then he skipped to the last square. He wanted to draw that one while it was still clear in his mind.

"Alfie?" his mother called from downstairs.

He jerked, making a line across his paper. Carefully he erased it and blew away the scraps of eraser. "What?" he called back.

"Are you *still* studying?"

"Yes."

"Well, come on down and keep Pap and me company."

"I will in a minute." He bent back over his work. His pale straight hair fell over his forehead.

He sketched in the giant, looked at what he had drawn, and erased it. The card table wobbled every time he erased. He wiped the scraps away. He tried again, erased that. He grimaced as he regarded his work. His mother had broken his concentration.

He twirled the pencil, batonlike, in his fingers. His thin fingers handled the pencil skillfully, and he began to draw again. He sketched lightly this time.

"Alfie!"

"In a *minute.*"

"Right *now.*"

Suddenly the light went out in the attic. Alfie knew what had happened. His mother had pulled the extension cord out of the wall below.

"*Mom!*" he protested.

"Well, I want you to come down here," she said.

"Mom, plug my light back in."

Silence.

Alfie sat in the dark. A patch of light slanted up from the living room. "Mom, plug my light back in," he said in a sterner voice. He sounded like Alma. "You want me to fail Science?"

"I'll give you—" she paused "—five more minutes—no, I'll give you till the next commercial." His mom didn't have a watch. She told time by television.

"Ten minutes," he bargained.

Silence.

He waited in the darkness. "All right," he sighed, "till the next commercial."

The light went on, and Alfie began to draw with renewed intensity. But he was in a hurry now, trying to finish before the next commercial. And when he tried too hard, he never did anything right.

He drew the giant's face. It looked distorted. The giant's nose looked like a three-leaf clover. He erased it. The last square was getting a gray, used

16

look. "I'll have to do this whole thing over," he muttered.

Below he heard the strains of a Diet Pepsi commercial. Abruptly his mom turned the volume up so he couldn't miss it. The light in the attic went off and on, off and on.

"I'm *coming*," he said.

He turned his paper face down on the table. He got up. To lift his spirits he held "Super Bird" to the light and looked at it one more time. Then he glanced up at the ceiling where his drawings hung. He began to climb down the ladder.

"Well, it's about time," his mother said. She turned down the television. "And I hope you're going to be better company than Pap." She crossed to the overstuffed sofa and sat.

Pap was sitting in a straight-backed chair. He looked and was unhappy. He had not gotten to discuss politics with the Governor because the Governor's wife, Bena, had a sinus headache. He sighed with discontent and indigestion.

He said, "TV's not as good as radio used to be."

Alfie sat down on the sofa by his mom. The springs were broken, and Alfie got the bad cushion. He sank deep. He didn't glance at his grandfather, because he knew what was coming and he didn't want to encourage it by appearing interested.

Pap said, "I was on the radio one time. Did I ever tell you about it?"

"Only one hundred and fifty thousand times," Alfie's mother snapped.

Pap went on as if she had not spoken. "It was the *Major Bowes Amateur Hour.* I did eleven bird calls and ended up whistling 'Listen to the Mockingbird.' I got more applause than anybody."

"Why didn't you win then?" Alfie asked in spite of himself.

"Because a little girl that looked like Shirley Temple did a toe-tap to 'God Bless America.'"

"Oh."

"Her relatives sent in more than two thousand cards and letters. If it hadn't been for her, I would have won, either me or the boy that played 'Lady of Spain' on the accordion."

Alfie glanced at his grandfather, then back at the television. That was the story of his family's life, he thought. Almost. Almost winning the *Amateur Hour.* Bubba almost getting a football scholarship to W.V.U. His mom almost getting the job at Moore's Jewelry Store. Alfie wanted to be different. He wanted to be more than almost.

"Let me see if I can still remember some of my bird calls," Pap said thoughtfully.

"Oh, Pap, not tonight," Alfie's mother moaned. "If I have to hear the purple-breasted sapsucker, I'll start screaming."

"All right, then, which one *do* you want to hear?"

"None of them. I'm trying to watch Dr. Welby, all right?"

"How about the bobolink? That was always your favorite when you was a girl."

"How about the loon? At least that would be appropriate," she said.

"Well, here's the bobolink for anyone who wants to listen."

"Pap, have mercy! You know whistling sets my teeth on edge." She put her hands over her ears, but carefully so as not to disturb her hairdo.

Unconcerned, Pap whistled the bobolink call. He ended, paused, and said, "Wait a minute, let me try that again. I'm getting rusty—haven't done my calls in a good while."

"In a good while! Pap, you did them last night! We sat right in this room and had our television disrupted for forty-five minutes while you whistled your head off. Isn't that right, Alfie?" She patted her hair. It was a new shade—golden wheat—and she was proud of it.

"Yes."

"Well, let me do just one more to make sure I remember. How about the whippoorwill?"

"Pap!"

As the call of the whippoorwill filled the small crooked room, Alfie's mom got up and crossed to

19

the television. She turned the volume up loud. Then she came back and flopped angrily on the sofa. The springs protested.

Alfie sat between the two noises—the television and the bird calls. He closed his eyes. In his mind he went over the drawing of the giant. Suddenly he knew what he had done wrong—he had tried to show too much of the giant. Just the head would be enough, with the ring held right at the front of the picture.

He smiled to himself. Tomorrow . . .

Chapter Three

"Hey, Lizabeth!" Tree Parker yelled. "Take my picture. Take a picture of me and Alfie."

Alfie said, "Oh, come on, Tree, will you? I got to get home. I got to study." It was after school, and Alfie was eager to get to his drawing.

"Well, can't you wait just one minute? I want Lizabeth to take our picture. Oh, Liz-a-beth!"

Alfie and Tree were standing on the sidewalk in front of Elizabeth Elner's house. Elizabeth was posing her cat on the front steps. The cat had on a doll hat and sweater. Elizabeth was spending a lot of time getting the angle of the hat just right. She ignored Alfie and Tree.

"All right, Lizabeth, we're going to leave," Tree warned. "This is your last chance to take our pictures." Tree loved to have his picture taken. The people he envied most in the world were the people at football games who managed to jump

up in front of the TV camera and wave.

Elizabeth stepped back and took a long critical look at the cat. "Now, don't you move," she warned. She looked through the lens of the camera and got the cat in focus.

"Watch this," Tree whispered to Alfie. He began sneaking up the front walk.

Tree had gotten his nickname in second grade when he had taken the part of a weeping willow in an ecology play. Not until the class saw him standing there, wrapped in brown paper, artificial leaves in his hair, did they realize how much like a tree he was. Now no one—not even the teacher—called him anything else.

Slowly, his long arms and legs angling out, glancing back to see if Alfie was watching, Tree moved closer to Elizabeth and the cat.

Apparently unaware, Elizabeth said, "Because if this picture comes out, I'm going to enter it in the Purina cat contest."

Tree slipped closer to the steps. Then just as Elizabeth was ready to snap the picture, he jumped forward, arms out, and said, "Scat!" He was like a bundle of sticks in motion.

The startled cat jumped to the sidewalk and disappeared in the bushes.

Elizabeth spun around. Her face was red. "*Now* look what you've done, Tree. If that cat snags my

sister's good doll sweater, you're going to get it."

"Oh, am I scared," Tree said. His limbs trembled.

"I mean it, Tree Parker."

"Come on, Tree," Alfie said. "I got to get home."

Elizabeth advanced. "If that cat comes back without his outfit—my sister only let me use it because I promised nothing would happen to it—and if he comes home without it, Tree . . ."

"What you going to do?"

"Let's *go*," Alfie said.

"Well, I want to find out what she's going to do. What you going to do, Lizabeth?"

"Just wait and see."

"Come *on*." Alfie grabbed Tree by the sleeve and pulled him away. Reluctantly Tree began to walk down the sidewalk.

"I wouldn't let her take my picture now if she got down on her knees and begged," he said. He spun around. "You're not taking my picture now, Lizabeth," he said.

"Then quit posing," she called back.

"I wasn't posing! Alfie, you saw me. Was I posing?"

"No," Alfie lied.

"Anyway, why didn't you help me? You never want to do anything anymore."

"She wasn't going to take your picture, Tree."

"I know, but if you'd have helped, we could have got the camera away from her and taken pictures of each other and of her trying to get the camera away from us. It would have been fun. Listen, let's go back and I'll distract her while you grab the—"

"I got to get home," Alfie said.

"I know. You got to *study*." The way he said the word showed what he thought of studying. "If you want my opinion you'd do better not to study so much. Look at me. I never study and I get all A's and B's." He broke off and turned to Alfie, smiling. "Hey, did I ever tell you about Lizabeth in kindergarten?"

"Tell me while we walk."

"You'll love this, Alfie. Her mom sends her to this special kindergarten, see, so she could get into first grade early—her birthday's in February. And in this kindergarten they have red day and yellow day and purple day and orange day and green day. And on red day, Alfie, you get red Kool-Aid and red stars for good work. On yellow days it's yellow Kool-Aid and yellow stars. So Lizabeth takes this test, see, to find out if she's ready for first grade, and the first question they ask is to name the days of the week. Lizabeth knows that. It's the one thing she's really sure of. 'The days of the week,' she says—you know how important her voice gets when she knows the

24

answer—'The days of the week,' she says, 'are red, yellow, purple, orange, and green!' That's why she flunked the test, Alfie, and ended up in our grade. That's why— Hey, let's double back and ask her what day it is. I'll say—"

"I gotta go, Tree. This is my corner."

"Oh, all right. Come up later if you get through with your *studying*."

They parted and Alfie walked toward his house. The house looked even stranger from a distance. A house made without a plan. Alfie liked the idea. Three men started building a house. "You two start at those corners. I'll start over here."

They'd begin. They'd hammer and saw and raise beams and lay bricks, and when they finally met in the center, they'd step back to admire their work. Their mouths would fall open in surprise. "Hey, are we building the same house?"

"I'm working on the Mason house."

"I'm on the Kovac job."

"Well, I'm doing the new Pizza Hut."

They'd consult their blueprints. "No wonder it looks so weird," they'd say, and leave, dragging their tools behind them. "If that don't beat all." It would make a nice animated cartoon, Alfie thought. Someday he'd do it.

He glanced down at his turned-in feet. His shoes were eating his socks as he walked.

He had once said he could make a cartoon about anything. Life was very close to cartoons, he had said, whether you liked it or not. That's why they were funny. Cartoons took life and sifted out the beauty, the sweetness, the fleeting moments of glory and left you as you really were.

He could do a cartoon about himself, he thought, about his turned-in feet. That was the stuff of cartoons, no beauty or sweetness, no moments of glory in turned-in feet.

In the first scene he'd be walking down the sidewalk with his turned-in feet and he'd meet a man with regular feet. The man would say, "Turn those feet out, son."

In the next scene he'd meet a woman. She'd say, "Better turn those feet out, sonny."

In the next scene he'd meet a group of children. They'd yell, "Hey, turn your feet out like us. Look at our feet. See how they turn out!"

In the last scene he'd meet a duck and a pigeon. They'd say, "Your feet look all right to us." And the three of them would waddle off into the sunset.

He smiled.

He came to the front door of the house and paused before entering. The smile left his face because he was afraid he couldn't get to the attic before his mother caught him.

"What happened at school?" she'd ask, eyes shining. She loved gossip, even about people she'd never heard of.

"Nothing."

"Oh, come on. *Something* must have happened."

"No."

"Come *on*. I've been sitting in this house with nothing but Pap and TV for company. What happened?" Sometimes she would make him tell her at least one thing before he could go to the attic. "Well, we had a substitute teacher in World Studies."

He opened the front door quietly. There was no one in the living room, but he could hear the rattle of dishes in the kitchen. Quickly, silently he climbed the ladder and pushed open the trap door. The warm attic air felt good against his face. He thought of this door as an escape hatch, like the kind on a submarine.

Long ago, when his father was alive, he had felt like this about the junkyard. His father, starting from nothing, had built up a wrecking business. He called himself the Wreck King of West Virginia. His junkyard covered seven acres. On top of the concrete building where his father conducted business was a huge crown made of hubcaps.

To Alfie, the junkyard had been as good as Disneyland. Car after car, some brand new, some

rusted and old, an ocean of cars that would never move again. To crawl into those cars, to work controls, to sit and dream was as good as a ride on a roller coaster.

Alfie especially liked to sit in the old Dodge sedan because every window in it was cracked and splintered, so that when the sun shone through, it was as beautiful as being in church. And the Chrysler Imperial—its windows had a smoky distortion, so that, beyond, figures seemed to float through the junkyard like spirits through the cemetery.

His last memory of the junkyard still hurt him. It was the day the yard was sold at auction. Alfie had sat on a wrecked Ford pick-up truck, on the fender where a dent made a perfect seat, and had watched the junkyard go to a man named Harvey Sweet. For a long time after that, Alfie had been as lost as a bird without a nest. Then he had found this attic.

Suddenly he heard his mother's voice in the kitchen. She was complaining to Pap. "Oh, I wish Bubba was here, don't you, Pap?"

"What?"

"Don't you miss him?"

"Who?"

"Pap, put down that paper!" Alfie heard her crumple it. "I'm talking about Bubba. Don't you miss Bubba?"

"No."

"Don't you ever miss anything?" she asked in exasperation.

He took the question seriously. "I miss the junkyard," he said after a moment.

Slowly Alfie let the trap door close. He knew what Pap meant about missing the junkyard. It was possible to miss a place more than a person, if the place was where you felt at home. And Pap had been more at home sitting on an old Coca-Cola crate in the shade of the hubcap crown than he had ever felt in his chair in front of the television.

He also understood why Pap did not miss Bubba. He himself was glad Bubba was gone— working at a gas station in Maidsville, married to a girl named Maureen. There was something about Bubba that overshadowed everyone, like the walnut tree in their old yard whose leaves were so thick nothing could grow beneath. Its shadow had been as black at noon as it was at midnight.

"Well, I do miss him," his mother said loudly below. She had come into the living room and was standing right below the trap door. "Something was always happening when Bubba was here. It was like all the life and all the fun went into Bubba, and the other children, well . . ."

Alfie wished suddenly there was an easy way to close the ears. He could hear too much in the attic.

You could shut your eyes, he thought, block out everything you didn't want to see, but the ears . . .

Alfie sat down quietly at his table. He did not turn on the lamp. A little light filtered in through the slits in the eaves, a soft dusty light like in very old paintings.

"Oh, I'm going out," his mother said below.

"Where to?"

"Out!"

"Well, if you're going to the beer hall, wait for me."

"You got any money, Pap?" she sneered. "They don't take food stamps."

"They take Social Security money, don't they? The government ain't made a law about how we spend that, have they?"

Alfie heard the front door close. He reached out and turned on the light. He looked up at his cartoons, his comic strips, his drawings.

With one hand he reached for a pencil, with the other a fresh sheet of paper. A slight smile came over his face. He was home.

Chapter Four

Alfie lay in his bed. He was staring up at the ceiling. He did not see the sheets of pale plywood or the dark nail heads, because in his mind he was looking beyond the ceiling into the attic.

Alfie squinted his eyes. He tried to imagine the house without ceilings, with only the rafters. He imagined his cartoons, Scotch-taped, pinned, thumbtacked to the underside of the roof, hanging down, enlivening the whole crooked house. He imagined people dropping by the house to look up at his drawings the way they went into the Sistine Chapel to see Michelangelo's.

Someday the attic would be famous. "This is where he began his cartoons," they'd say. There would be people filing through, climbing, one by one, up the ladder to the attic. There would be a souvenir stand where copies of his comic strips could be bought and machines where his cartoons could be viewed for a quarter.

He shifted and sighed. He was restless. He could not fall asleep. He knew this was because of the comic strip he had drawn after supper. He had been so pleased with it that he had taken it down to show his mother.

"What's this?" Squinting, she had turned it first one way and then another, as if it were a modern painting.

"Like *that*," he had said, putting it right. He looked over her shoulder with a pleased, expectant smile. It was the strip about his turned-in feet, and she would *have* to laugh at that. When he was little, she had laughed about his feet all the time and called him "Duck" and "Pigeon." For the first time he had felt secure about pleasing her.

"What is this thing?"

"It's a comic strip. I drew it."

She held it at a distance to see it better.

"It's about me," he went on. "Don't you see the feet?"

"What feet? Turn up the light, Pap."

"It's up high as it can get," Pap said. "Forty watts is forty watts."

She tried turning the strip of paper sideways.

"Never mind," Alfie said angrily. He snatched it from her. The paper tore.

"I *want* to see your drawing," she said, offering to take it again.

"Never *mind.*"

"Well, just 'cause I can't tell which way is up, that's no reason to get mad, is it, Pap?"

"Getting mad runs in our family," Pap said, leaning back, getting ready to start a story. "Did I ever tell you about the time Cousin Cooley and me—"

"Yes!"

"I got to study," Alfie said.

"Leave your drawing or your cartoon or whatever it is, honey, and I'll look at it in the morning."

Holding the comic strip to his chest, he went quickly to the ladder.

"Well, the way it started was that Cousin Cooley had got himself what he called an antique can opener, bought it off—"

"Pap!"

"—bought it off Jimmy Hammond at the hardware. Well, soon as I seen it, I knew that . . ."

Alfie slammed the trap door shut, and he had sat in the attic until they were all in bed. He had heard the water in the basin as Alma washed her hair, the brushing of teeth, the flushing of the toilet, the dropping of bobby pins, and then finally the snores.

He pushed aside his blanket. They were all snorers. Pap was the loudest. Alma was the quietest, with just a ladylike wheeze. He had told her that

once as a compliment and she had erupted like a volcano. "Don't you ever say I snore! I do not snore!" His mom snorted every once in a while as if she had thought of something funny.

Alfie closed his eyes. He suddenly found himself thinking, as he had earlier, of the one and only time he had made his mother laugh.

He and Tree had been coming down Elm Street one evening on their way home from the Fall Festival at school. Tree had been talking about the general sorriness of the booths. "Did you go in the Haunted House, Alfie? It was in Mrs. Lorensen's room."

"No."

"Well, some girl in a witch suit—I think it was Jenny DeCarlo—said, 'And now you have to feel *eyeballs,'* and I knew it was going to be grapes, but, Alfie, these grapes weren't even *peeled*—" He broke off abruptly. "Hey, what's going on at the corner?"

Ahead they could see two people pushing a car down the street. Alfie and Tree edged closer, sensing the two people were not just trying to get the car started. Moving from the shelter of one tree to another, they got closer. When they were almost at the corner, Tree said, "Hey, that's your brother! That's Bubba! What's he up to?"

Alfie ran forward in his concern. "What are you doing, Bubba?" He glanced over his shoulder at the deserted street behind him.

Bubba, smiling, turned to Alfie. The other boy was Goat McMillan.

"Is this your car, Goat?" Tree asked. He was standing apart, keeping himself separated from what might be trouble.

"No, it's not his car. Goat wouldn't have a car like this, would you, Goat?" Bubba said.

"Not if I could help it."

"But whose car is it?" Alfie asked.

"It's Perry Fletcher's." The sound of the name on Goat's lips caused Bubba to double over the fender with laughter.

"Who's he?"

Bubba and Goat were laughing too hard to answer. Alfie reached out and touched the sleeve of Bubba's football sweater. "Who's Perry Fletcher?"

Bubba straightened. "Perry Fletcher's this boy, see, and all he can do is talk about his car and his boat and his stereo and how wonderful everything he owns is. So me and Goat see Perry Fletcher park his car in front of Maria Martini's house and go inside. We know the car's brand new, see. We know this is the first time he ever drove it."

"But why are you pushing it down the street?" Alfie asked in a worried way.

"Because we're going to hide it in somebody's driveway," Goat explained.

"Yeah, and then we're going back and sit on

35

Goat's porch, see, and watch Perry Fletcher come out and find his new car gone."

Goat broke in with, "If I know him, he'll call the fuzz first thing. 'Officer, Officer, come at once. I've been robbed!'"

"Hey—hey—" Bubba was laughing so hard he could barely speak. "Hey, let's hide it in *Big Bertha's* driveway!" Big Bertha was their algebra teacher.

"I don't think you ought to be doing this," Alfie said. Again he glanced up and down the deserted street.

"Yeah, we'll put it in Big Bertha's driveway," Goat said. "Hey, this is better than Friday." He turned to Alfie and Tree. "See, last Friday we let the brakes off Ted Copple's Buick and pushed it into a tow-away zone because Ted Copple wouldn't let me copy his math, and then we went in a phone booth and called the police and pretended to be irate citizens —Morrie Hutchinson was the irate citizen—and he demanded that the police do something about illegal parking in front of the high school. Ten minutes later Brant's tow truck arrived. It made my day."

"I gotta go," Tree said.

"Me too," Alfie said. They turned together and began running up Elm Street.

"Wait, you can help us," Bubba called.

"Yeah, Alfie, we may need help getting up Big Bertha's driveway!"

At the top of the hill Alfie and Tree separated without a word. Alfie cut through the park. The swings were moving slightly in the wind from the river. He ran around them. He stumbled over his feet and fell.

On his knees in the dust by the swings he remembered that when Bubba had played in this park, he could swing higher than anybody. And at the peak of his swing he could slide off the seat, easy as grease, fall through the air, and land, catlike, on his feet. Another boy who tried it landed so hard in a stoop that he had bitten a piece out of his knee.

Alfie got to his feet. Running again, he left the park and ran through the Lanleys' yard. A dog barked. He entered the apartment building where they lived at the time.

He looked so wild as he entered that his mother asked him what was wrong. Gasping for breath, he broke into the story of Bubba and Perry Fletcher's car.

Halfway through the story he faltered. He realized his mom would be furious with Bubba. She would probably throw on her coat and go looking for him. Bubba would never forgive him.

Instead he saw that his mother was beginning to laugh. He hesitated, puzzled.

"But, Mom, this could be car theft."

"Not if he doesn't get in the car," she said. "Any-

way, go on." She reached forward and turned off *I Love Lucy* so she could get a real laugh. "Now, start from the beginning and tell me every detail." Her eyes were shining. "Don't leave out a thing."

He told it again, slower, standing as rigid as if he were in front of his class giving a report.

She laughed so hard at this second telling that she had to have a tissue. When she dried her eyes, calm at last, she said, "Do me a favor."

"All right."

"Don't let Bubba know you told me."

"All right."

"I want to hear him tell it too. Can't you just imagine them sitting on Goat's porch? Can't you just imagine the expression on Perry Fletcher's face when he— Hey, get me Bubba's annual. I want to see what he looks like." The picture of Perry Fletcher in the annual set her laughing again. "I *knew* he'd look like that. He's the only boy on this page who's got on a tie."

Alfie shifted in his bed again. On the ceiling the lights of a car passing on the street below reflected, moved, disappeared. In the next room his mother snorted in her sleep.

Maybe he could do a cartoon about it, Alfie thought. That was what artists were supposed to do—turn life's painful experiences into art.

He imagined two boys pushing a car down the

street. It was too real. He imagined an old man and a woman pushing a funny-looking car down the road. That was better. They would be hot and sweaty. The old woman's hair would be flying out from her head. The old man's shirt sleeves would be rolled up. The old woman would be snapping at the man. "Sure you invented the car! I want to know when you're going to invent the *engine!*"

Maybe his mother would laugh at that, but he didn't think so. Planning a better cartoon, he fell asleep.

Chapter Five

At his school desk Alfie was drawing a comic strip about a dog. The rest of the class was working math problems.

Alfie had gotten the idea for his strip that morning during breakfast. Alma was talking about an article she'd read. "It said you shouldn't buy this kind of cereal, Mom."

"Why not?"

"Because it's got additives in it. Look on the box—artificial coloring, artificial flavoring—just read what we're eating."

Pap said, "It's better than hot dogs. There's rat hairs in them."

"Not at the table, please, Pap," Alfie's mother said.

"And where there's rat hairs, there's probably rat—"

"Pap!"

40

"—droppings."

"*Pap!*"

"Let *me* buy the cereal from now on, all right, Mom?" Alma said, getting up from the table.

Alfie was dipping his spoon into his soggy cereal, thinking up a comic strip about artificial flavoring.

"Alfie, are you going to sit there all morning or are you going to school?" his mom said finally.

"Don't bother me right now."

"Well, you're lucky to have somewhere to go, isn't he, Pap? Don't you wish you could go to school?"

"No."

Now Alfie had finished his comic strip. He had intended that as soon as he finished, he would begin work on his math problems, but now he sat admiring his work. His math was forgotten.

In the first square a large dog was reading the label on a can of dog food. "Artificial flavoring."

In the second square the dog was reading the label on a box of dog biscuits. "Artificial coloring."

In the third square the dog was reading the label on a dog collar. "Artificial fibers."

In the fourth square he was howling, "Is everything artificial these days?"

In the last square a little sign comes up from the dog's fur. "Fleas are still real!"

41

Alfie was very pleased with it. He wanted to take it up immediately and show it to his teacher, but she would know he had done it during Math.

"All right," the teacher said, "time's up. Change papers with your partners and we'll check our work."

Alfie looked up, startled. He glanced at Tree. Dutifully Tree was holding out his paper to Alfie. "Go easy," he said. He waited a minute with his hand outstretched and then he said, "Come on. Give me your paper." He snapped his fingers with impatience.

"I didn't do mine," Alfie whispered back, hiding his comic strip under his notebook.

"Why not?"

"I just didn't."

"But then I don't have anything to check!" Tree complained. He was upset. He loved to grade papers. It gave him a feeling of power. Grading papers made him want to become a teacher when he grew up.

"What's wrong back there, Tree?" Mrs. Steinhart asked.

"Nothing."

"Alfie? Anything wrong?"

"No."

"All right then, we'll go over the first problem." Mrs. Steinhart began to put the problem on the

board. All the class bent over their papers.

Tree leaned forward too, hunched miserably over his bare desk. He shot Alfie a resentful look. Alfie did not glance at him. He was going over Tree's first problem.

Tree punched Alfie to get his attention. Then he acted out the difficulty of grading an invisible paper.

"Tree?" Mrs. Steinhart called.

He looked up.

"Is anything wrong?"

"What could be wrong, Mrs. Steinhart?" This was what he always said when something was wrong that he was not free to discuss. He had gotten this from his sister, who had gotten it from soap operas.

"Whose paper are you grading?"

Tree looked down at his bare desk, the pencil in his hand. He sighed. "Alfie's."

"Bring it up here, please."

Tree's mouth fell open. He stared down at his desk. Finally he looked up at Mrs. Steinhart. "I can't find his paper, Mrs. Steinhart, that's what we were muttering about."

Alfie cleared his throat. "The reason he can't find my paper, Mrs. Steinhart, is because I didn't do it. My mind was on something else."

"Oh." There was a pause, and then Mrs. Steinhart said, "Well, then we'll continue without Alfie.

43

Tree, give your paper to Maurice and you can grade Elizabeth's paper."

Tree's face lit up with delight. "Yes, *ma'am*!" He snatched his paper from Alfie and made the exchange. He took Elizabeth's paper with a flourish. "Revenge," he whispered happily. He pantomimed making big X's beside every one of her problems. "Is she going to be sorry she didn't take our picture yesterday!"

Alfie sat without moving. He thought about going up to Mrs. Steinhart after class and explaining why he didn't do his math, but he knew he didn't have a good enough reason. Not comic strips. She wouldn't buy that. Maybe he could say he had an attack of something. He sat silent and miserable.

Tree punched him. "She missed number three," he whispered, his voice rising with delight, "subtracted instead of added." He bent over Elizabeth's paper again, pencil poised for action. He began to whistle through his teeth. Alfie slumped lower at his desk.

Beside him Tree straightened abruptly. His hand shot into the air. "Oh, Mrs. Steinhart," he called, "is that a two or a three on the second line?"

"It's a three." She went over the number with her chalk.

"That's what I was afraid of!" Tree said, singing the words in his joy. He made an elaborate X beside

44

the problem. To Alfie he hissed, "She's missed two out of five. Bet she's really sorry she didn't take our picture!"

Alfie nodded by lowering his head. He lifted his notebook and glanced at his comic strip of the dog. He pulled it into view. It made him happy when one of his cartoons came out just right, but now he didn't smile.

Tree's long arm was waving in the air again. "Oh, Mrs. Steinhart?"

She sighed. "Yes, Tree."

"How many can you miss and still pass?"

"This isn't a test, Tree."

"I know, but if it *was* a test?"

"Well, there are ten problems. Everyone should get at least seven, though I would like to see everyone have a perfect paper.

"Too late for *everyone* to get a perfect paper, Mrs. Steinhart," Tree said cheerfully. Tree nudged Alfie. "If she misses one more she's—" He made a down gesture with his thumb.

Alfie nodded without enthusiasm. He took his comic strip and slipped it carefully in the back of his notebook in a pocket for special papers. When he got home he would put it up on the rafters in the attic. It deserved a place of honor, he thought, even though it couldn't cheer him up now.

Also in the pocket was a comic strip he had

done the day before during English. He pulled it out and looked at it. "Super Giant."

In the first square the giant was destroying a forest, ripping trees from the earth, crying, "I love violence."

In the second square the giant was destroying a village. "I *love* violence!"

In the third square the giant was destroying a farm. *"I love violence!"*

In the last square the giant was flattened on the ground, being attacked by the villagers, the farm people, and the forest animals. He was saying, "It's things like this that take the fun out of violence."

The strip hadn't come out the way Alfie had wanted it to, and although he had spent most of English and Science trying to correct it, he had not succeeded. He saw now that he had failed because he had tried to put too much into each square. Perhaps if he . . .

Beside him Tree was desperately going over Elizabeth's paper one more time.

"Give me my paper, Tree," Elizabeth said. She tried to snatch it from him.

"In a minute, in a minute." He waved her away with his long arms. "I just want to make sure there aren't any more mistakes."

"Tree, give me my paper. Mrs. Steinhart, Tree won't give me my paper."

"Tree."

"I'm just trying to be thorough, Mrs. Steinhart, like you taught us. I know there's another mistake here. I just can't find it."

Elizabeth snatched her paper from him. "I'm rechecking this whole thing, Tree, and you better not have made any mistakes either."

"Me? Make mistakes?" Tree said. He looked as lofty as if he were in the forest, glancing down at a mere sapling. He took his own paper from Maurice. He fell silent.

"By the way, how many did *you* miss, Tree?" Elizabeth asked scornfully.

Tree didn't answer.

"All right, class," Mrs. Steinhart said, "pass the papers to the front of the room, and, Alfie, I want to see you after school for a few minutes."

Alfie closed his notebook. He shook his hair out of his eyes. "Yes'm," he said.

Chapter Six

"What'd she want?" Tree asked. He had been waiting for Alfie. He was leaning against the lone schoolground tree, his foot propped on a root. He seemed part of the landscape.

"Nothing," Alfie said.

A line of boys and girls were waiting to board the school bus. One of the boys called, "What'd she do to you, Alfie?"

"Nothing." He kept walking. All the grass had been worn off the schoolyard, and the dirt was packed as hard as concrete.

Tree fell into step with Alfie. "What *did* she want?"

"If you *must* know—"

"I must."

"—she wanted to tell me I'm flunking Math."

"That's supposed to be news?"

"Also she wants a conference with my mom."

"She must not know your mom."

Alfie kept walking, watching his feet.

"Nothing against your mom," Tree went on. "I just can't imagine anybody wanting to have a conference with her."

Alfie said nothing. He had made a terrible mistake in his talk with Mrs. Steinhart, one he regretted deeply. In the middle of the talk, he had abruptly decided to take her into his confidence and show her his comic strip about the dog. This had been for two reasons. First, he really liked Mrs. Steinhart, and, second, he did not want her to think he was just goofing off during Math.

"Wait a minute," he had said.

He had hurried back to his desk and gotten his notebook. He had carried it to her, opened it, and carefully pulled out the comic strip. He had laid it before her like a fabric salesman.

"What's this, Alfie?" She put on her glasses.

"It's a comic strip, Mrs. Steinhart. I drew it myself."

"This is what you were doing instead of your math problems?" she asked.

"Yes."

She looked at the strip. Alfie watched to see if a smile would come over her face. It did, but it was too faint to count. When she looked at Alfie the smile was gone. "You like to draw, don't you, Alfie, cartoons and things?"

"Yes."

"But—" She got even more serious. She took off her eyeglasses. "But don't you think, Alfie, that there are times to draw—we do have Art, you know."

"I know," he said quickly. The week before they had cut out and colored Indian symbols. School art was as different from cartoons as Science was from recess.

Mrs. Steinhart was still talking. "And then there are times for Math and for English and for Science." She made it sound as exact as sorting mail.

He picked up his drawing and slid it back in the pocket of his notebook. "Yes."

"Your cartoon is really very good, and I think there's a lot of humor in it."

"Thank you."

"And you've made a good point about the way we live today. There *are* too many artificial things. I myself have started reading the labels on everything I buy."

"Thank you."

"Only you're going to have to do your cartoons after class."

"I know."

"I don't want to see you drawing again."

"You won't."

"Good." She smiled at him, a big smile now, the one he had wanted to see earlier when she had first

looked at his comic strip. "You're a smart boy, Alfie, and I want you to do as well as I know you can."

"That's what I want too." He paused. "Can I go now?"

He had stumbled over his feet as he left the room. All the time he had been drawing his cartoons, he had secretly felt that they were touched with genius. He had known that if he had shared them with other people, they would have been as delighted as he. Now he *had* shown them—to his mother, Pap, Mrs. Steinhart—and nothing had happened.

Beside him Tree was talking about a conference he had had with Mrs. Allen in first grade. "I didn't know what I was doing, Alfie. I loved to make letters, see, but they didn't have any meaning for me. Little *b* and little *d* were my favorites, but even they were just circles leaning against sticks.

"Anyhow, the way Mrs. Allen found out I was copying off other people—you'll love this, Alfie— was because I'd *copy their names too*! I didn't know it was their names. It was all just a bunch of circles and sticks to me but—"

Suddenly Alfie stopped. He said, "I got to go back. I left my notebook on Mrs. Steinhart's desk." He didn't know how he could have done such a thing.

"Aw, you can get it tomorrow," Tree said. "Any-

way if you go back in there, she'll say, 'Oh, I'm glad you're back because there are a few more points I'd like to make about your conduct.'"

"I got to go back."

"I'll lend you some paper if that's—"

"I've got to have my notebook!"

Tree stopped and looked at him in disgust. "What you got to have—your *pictures*?" He made a scornful sound as he said the word *pictures*.

"What?" Alfie stopped walking.

"Your *pictures*. Those things you draw all the time. What are those things anyway?"

"I don't draw."

"I see you. Today you were drawing a dog. Yesterday it was a giant. Last week it was an octopus."

Alfie stood without moving. He felt sick. He didn't know anyone had been watching him. He said angrily, "I was not drawing a giant."

"I saw you! Look, this is me, Tree. I can see everybody in the class."

"You didn't see me drawing a giant!"

"Well, all right," Tree said, bending. "Maybe it was a picture of a huge enormous man."

Alfie said nothing.

"Which, I may point out, *is* a giant."

Alfie stared up at Tree. There was a hard moment between them. They had been friends since second grade, and yet the friendship had sud-

denly gone sour. They seemed to move apart, even though no footwork was involved.

"And today," Tree went on in the same loud tone, "I guess you weren't drawing a picture of a dog."

Alfie said nothing.

"So, all right, maybe it was a picture of a *canine*."

Alfie said nothing.

"Which, I may point out, *is* a dog!"

Without a word Alfie turned and started for home. When he got to the corner, Tree relented and called to him, "Oh, come on, Alfie, I'll go back with you to get your notebook."

Alfie kept walking.

"I was trying to keep you from going back for *your* sake. One conference a day is enough. Listen, I was thinking of *you*!"

Alfie did not turn around. He kept walking at the same pace like a robot. There was a silence. Alfie had almost reached the next block when Tree called, "All right, be that way!"

Chapter Seven

Alfie walked slowly up the front path to his house. He stopped at the steps because he could hear his mother and Pap arguing in the living room. He knew there was no way he could get to the attic without being drawn into the fight.

"Well, I'll tell you what you can do," Pap was saying in a hurt, angry voice, "just get rid of me. That's what you're driving at. Send me to the poorhouse!"

"They don't have the poorhouse any more and you know it."

"The government's even took that away from us," Pap said. He was mournful now.

Alfie stood with his toes touching the bottom step. He looked down at his turned-in feet.

"Well, then send me to the Nursing Home for Christian Gentlemen," Pap said.

"Whoo, you think they'd have you?" his mom snapped. "You do not *quite* qualify. Besides, that

place costs over two hundred dollars a month."

"Well, what do you want me to do then—just disappear? Want me to go off like some old tired elephant to the burial ground and—"

"Pap, don't start in on the old-elephant routine now. I just can't take it." His mother's tone changed abruptly. "All I want you to do," she went on slowly, "is to help me." She was wheedling now, trying to get Pap in a good mood.

"I ain't cutting no hole in no wall."

"Aw, Pap."

Alfie sat down on the steps. He looked at the ground.

All the other houses they had lived in had had bushes by the door, hiding places. On Tenth Street there had been a regular tunnel behind the shrubbery. Alfie could duck through the low branches at the front door and come out by the back door without anybody seeing him. He missed that now. He would have liked someplace to crawl into, a place to wait out the storm.

His mother was saying, "You just don't know how important this is to me, Pap." Her voice sounded louder. Alfie imagined that she was close to the window now, perhaps ready to look out and see him sitting there. "Well, here's Alfie," she'd cry. "We'll let him decide." She loved to have a referee.

Alfie got up quickly and ran down the dirt path

to the street. He hesitated a moment and then turned toward town. He had no plan, but as he walked it occurred to him that this would be a good time to check with Logan's Printers and Binders to see if they had any more scrap paper for him.

The thought made the air feel suddenly fresh and good again. He breathed deeply. His shoulders relaxed. A box of new paper, all different sizes and kinds, some sheets thin enough to trace through, others thick as cardboard—that was all he needed to bring back his good feeling. He imagined himself in the attic, sorting out the paper, putting it into piles, cutting off the letterheads and smudges. He began to walk faster. He remembered that the man had promised to save all the scrap paper for him. By now there was probably a mountain of it. He imagined himself falling into the mountain of paper the way farm people fell into haystacks. He—

"Hey, Alfie, where are you going?"

He turned and saw Alma coming down Grant Street. She had a bag of groceries in one arm and a carton of Cokes in the other. Her long hair was tied back with a scarf.

"I got to go downtown," he called back. He wished he had thought to borrow a wagon from the little boy next door. He would probably need a *truck* to carry all the paper they'd saved for him.

"Did you hear the wonderful news?" she called.

Alfie could tell from the way she said the word *wonderful* that the news was very bad indeed.

"What's happened?" He waited, toes touching, while she walked toward him. She set down the Cokes and shifted her bag of groceries to the other arm.

"Bubba's coming home."

"What?" He leaned forward a little.

"Bubba," she repeated slowly, "our *wonderful* brother, and Maureen, his *wonderful* wife, are coming to live with us."

"But that couldn't be," he sputtered. His words went too fast, like a speeded-up tape recorder. "Why would they be coming to live with us? They've got an apartment in Maidsville. Bubba's job is there. He—"

"He got fired."

"But how could that happen? What's going on? I thought the man at the gas station really liked Bubba. That's what Mom said. She said the man wanted Bubba to be like a son to him. She said he was going to let Bubba buy into the station. She said Bubba might even inherit the station when the man died."

"Bubba took one of the cars at the gas station— borrowed it, he said—because he had to drive over and pick up Maureen at the doctor's office. She's going to have a baby, by the way. That's another

wonderful surprise. And coming back to the station in this *borrowed* car, he ran a stoplight and hit a police car broadside."

"A police car?"

"Yeah, trust Bubba to go for the spectacular."

"But if he borrowed the car—"

"Borrowing without asking, Alfie, is stealing."

"But how could he do such a thing?"

"With Bubba it just comes naturally." She sighed. She shifted the groceries again as if they were getting heavier. "Anyway, they're going to live with us until Bubba can find another job, which is not going to be easy. It took him seven months—if you recall—to get the job in Maidsville and it was only because of Maureen's dad that he got that."

"But if he hit a police car, maybe they'll arrest him," Alfie said, speaking in a rush. "After all, a crime against a policeman is supposed to be worse than anything."

Alma shook her head. "All he's charged with is ignoring a stoplight and reckless driving."

"But he stole the car from the station, didn't he? That's a crime."

"The owner of the station is covering that up because he doesn't want the bad publicity. He says that if Bubba pays for the damage—though what Bubba's going to pay for it *with*, nobody has

58

said." She gave Alfie a hard look. "If you've got any money, hide it."

"I haven't."

Alma looked past Alfie to the river, where some coal barges were moving slowly. "We're never going to be free of Bubba," she said in a low voice.

Alfie turned and looked at the barges too. He felt close to Alma for the first time in years. It was like on the *Titanic,* he thought or the *Hindenburg,* where perfect strangers suddenly became best friends. Mutual tragedy did bring people closer together. He reached out to take her groceries.

"Well, I got to get home," she said, moving away before he could do it.

Suddenly Alfie's mind turned to the crooked house—the two bedrooms, the living room, the bathroom, the kitchen. That's all there was, he thought. The sofa in the living room didn't even make into a bed.

"But where are they going to sleep?" Alfie asked, following her. He went over the sleeping arrangements. He and Pap shared one bedroom; Alma and his mother, the other. There was no room for Bubba and Maureen. His hopes rose. "There's nowhere for them to sleep!"

"Mom's going to fix up the attic."

For a moment he felt as if he had been hit over the head with a hammer. He was paralyzed.

"The attic?" he muttered.

"Yeah, she's got it all planned. She's getting a window from Mr. Wilkins, and she's talking Pap into cutting a hole in the eaves and installing it. Then she's getting a double bed from Hill's Used Furniture and *my* dressing table and—"

"But the attic belongs to me." He stammered for the first time since he was three. His knees felt weak. In his mind the attic wavered like a desert mirage.

He had once watched an old apartment building on High Street being demolished. A huge ball had pounded into the walls, and they had crumbled. As the dust settled, Alfie could see pieces of people's lives shimmering in the air—the old faded wallpapers they had chosen, the linoleum they had walked on. An old curtain had flapped from a third-story window. Finally everything had sunk into a mound of dust. His attic crumbled now in the same way, his cartoons fluttering down through the dusty air like autumn leaves.

"The attic *used* to be yours," Alma corrected.

"No, it's *mine*."

"As soon as I get home with the cleaning stuff, Mom's going to start on it, and tomorrow—if she can talk Pap into it—the window will be installed, and by noon it'll be Bubba's bedroom."

"Mom wouldn't do that to me."

"Alfie, Mom would do anything for Bubba. Haven't you learned that by now?"

"It's *my* attic."

"Nothing has ever been yours and mine, Alfie, not since the day we were born, not if Bubba wanted it. Do you remember the time Mom took my baby-sitting money to pay Bubba's fine? Well, you probably don't remember because it was two years ago, but I'll never forget it. I was saving my money so I could go to Florida with the band, and my bank was almost full. I was so proud. And then I came in one night and put on the light and started over to put my baby-sitting money in the bank—remember I had a great big bank shaped like a globe? And I saw that it had been broken open. Pieces were all over the floor. I stopped. I couldn't move. I thought a burglar had done it. I was getting ready to go next door to call the police. And then I saw Pap standing in the doorway, and he said, 'Your ma had to have some money for Bubba. He's in trouble with the police.'

"Well, I just stood there. I couldn't move. I could see Mom's shoe by the bank—she had cracked it open with the heel. And all of a sudden I went over and I took that shoe and I beat the rest of my bank until it was dust. Everything was dust. The Atlantic Ocean, the Pacific, Russia, Africa, the Fiji Islands." She gave a sad laugh. "I guess I would still be there

beating the world to dust if Pap hadn't stopped me.

"Do you remember now? I think you cleaned up for me. And you have to remember me crying. I cried so hard Pap wanted to take me to the University Hospital. He thought I was cracking up." She sighed. "I guess I *was* cracking up in a way because, Alfie, that bank really was the world to me in those days."

"They're not taking my attic." His face looked so pale and strained that Alma shifted her groceries to reach out and touch him.

"Hey, it's not the end of the world," she said. "It wasn't for me. I admit it took me a long time to get over it. I still feel bad about it sometimes but—"

"They're not going to take my attic."

She shook his shoulder gently. "Hey, look, it's—"

He glanced at her without seeing her. "Nobody's going to take my attic." Twisting away from her hand, he turned and began to run for home.

"Wait, Alfie," Alma called. "Wait!" Clutching the groceries, she hurried after him.

Chapter Eight

As he ran past the Hunters' house, his mother stuck her head out the door and called to him. "Alfie!" He didn't look at her. "Alfie, stop. Wait a minute! I've got some wonderful news."

Alfie kept running. He took the steps in one bound, went down on his knees, got up, lunged for the screen door, pulled himself up by the knob, and entered. It was all one long awkward motion.

His mother started after him and called back to Mrs. Hunter, "I'll send Alfie and Pap over for the chest of drawers after supper." She paused to adjust her thong sandal. "And Bubba and Maureen will take real good care of it."

Alfie plunged across the living room. He grabbed the ladder as a man being swept away in a flood grabs for a tree. He swayed in the current.

Pap loomed up in the kitchen doorway, filling it. He held a coffee mug in one hand, a jelly dough-

nut in the other. "Did you hear the news?" He paused to lick some jelly from the side of his thumb.

Alfie started up the ladder. He felt the pull of gravity for the first time in his life. His feet were lead. His pants were nailed to the floor. He would never reach the attic.

"Bubba's coming home," Pap said.

Alfie struggled for the next rung of the ladder. He swayed with the unseen current. He struck his head on the wall.

"Bubba *and* Maureen."

Alfie reached up with one shaking hand. He pushed at the trap door. It was heavy. Usually it sprang open at his touch. Now it wouldn't budge. He went up another rung of the ladder. He put his head to it. Goatlike, he began to shove the door open.

"I don't mind him coming so much as I do her," Pap said, sitting on the sofa. "I don't know why Bubba had to marry a girl that pops gum all the time." He licked his thumb again. "And she'll leave it anywhere. One time I found a big wad of bubble gum in my tooth glass. It scared me. I thought my teeth had shriveled."

Heaving as if he had climbed a tall mountain instead of a ladder, Alfie pulled himself into the attic. He crawled forward. He let the trap door shut

behind him. The slam was like a cannon firing, the first shot of a long and difficult war.

"Alfie!"

He lay stretched out on the dusty attic floor, completely spent. Faintly he heard his mother call him as she came in the front door.

"Alfie, don't go up in the attic. I want to talk to you. I've got some great news."

"I done told him the great news," Pap said from the sofa.

"And guess what, Pap? Mrs. Hunter's got a chest she's going to let me use. She just covered it with contact paper—red and orange pansies—and it's going to really brighten up the attic. I'm getting so excited. Look at me, Pap. My hands are trembling."

In the attic Alfie's hands were trembling too. He got slowly to his knees.

When he had first started doing his cartoons in the attic, he had worked out a way of locking the trap door so nobody could come up and catch him unawares. Now he took the board and slipped it over the trap door and under the floorboards on either side.

"Alfie, what are you doing up there?" his mother called. "Come on down. I want to talk to you." She said to Pap, "Is there any coffee left?" She went into the kitchen.

On his knees Alfie stared blankly at the trap

door. The board was in place now. No one could open it.

He heard his mother walk back into the living room. "Alfie, do you hear me? Listen, Bubba and Maureen are coming home. They called this morning. It's going to be like old times around here. We're going to make a little apartment up there in the attic. Alfie?"

There was a pause while she blew on her coffee and took a loud sip. She raised her voice. "Alfie, do you hear me? Now listen, you and Pap and Alma are going to have to help me or I'm not going to be able to get everything done."

Alfie heard the front door open and shut. He heard Alma say, "Where's Alfie?"

"He's up in the attic and I can't make him hear me. Did you get the 409 cleaner?"

"Yes, Mom, but Alfie—"

"Because that attic is going to need a real scrubbing. I know it is."

"Mom—"

"And I'll need you to fix supper for me. I *know* you've got to go to work but—"

"Mom, will you listen to me for a minute?"

"Not now, Alma. Alfie, will you come down?"

"Mom, will you listen to me! Alfie is very upset about this. I just—"

"Upset about what?"

66

"About Bubba coming home and taking his attic."

"*His* attic? Since when has it been *his* attic? I'm the one who pays the rent."

"Mom, the attic has been his ever since we moved in here and he's got all his stuff up there and—"

"What stuff? I didn't see anything but an old card table and a bunch of papers."

"Well, those are his special things, Mom, and—"

"All right. He can move them into the bedroom, can't he, Pap?"

"Not in my half."

"Well, we'll make space. Anyway, once he realizes Bubba's coming home—why, he worships his brother, Alma, he always has, and he'll have fun helping with the arrangements. He can paint the headboard for me and—"

"Mom, Alfie doesn't even *like* Bubba, much less worship him."

"Alma, that's an awful thing to say."

"It's the truth."

"My half of the room ain't even got room for a postage stamp," Pap said.

"Pap, will you shut up? And, Alma, if I wasn't so busy, I'd give you a good talking to. Alfie has looked up to Bubba all his life."

"Mom, Alfie does not like Bubba. That is a fact.

Here's another fact. I don't like him either." Alma spoke very clearly, pronouncing each word separately so she could not be misunderstood.

There was a long pause. "You still hold it against Bubba, don't you?" his mother said finally in a low, flat voice.

"What exactly do you mean? I hold so many things against him, Mom, that I don't know which one you're talking about."

"I'm talking about the time that I used a tiny little bit of your precious baby-sitting money to—"

"I don't want to hear about that, Mom."

"—a tiny little bit of your precious money to keep your brother out of trouble. I should have thought you would have been glad to help, but I see that you still begrudge him that money."

"Mom, I said I don't want to talk about it."

"It doesn't matter at all to you," his mother went on, "that Bubba was just having a little fun after the football game. He *won* the game for them that night, you know. It was *his* touchdown that won the game, and afterwards he deserved a little fun."

"It wasn't a little fun," Pap said. "Giovanni don't call the police for a *little* fun."

There was a silence. Alfie rose. His knees cracked as he got to his feet. He could hear his mother set her coffee cup heavily on the TV. He heard her sigh.

"All right," she said in a cold, hurt voice, "I will see that your precious money is paid back, Alma, every penny of it. I didn't know that you still *begrudged* . . ." She made begrudging sound like the worst thing a person could do.

Alma said nothing.

"Just don't bother me about it now and I will pay every single penny back!"

There was another, longer silence. Alfie stared down at the barricaded trap door. There was no expression on his face. He felt strange now, as if he were looking through the wood, seeing the three of them—Alma, his mother, Pap. They were as small and distant to him as figures seen from an airplane.

When his mom spoke again, her voice was trembling. "All my life, it seems like every time I need people, they all of a sudden turn against me."

Alma sighed. "I haven't 'all of a sudden' turned against you, Mom."

"Well, you won't help me. You're bringing up old stories that hurt me and make me feel bad. Look how my hands are trembling."

"I didn't bring up anything, Mom. Anyway, I *am* helping. I went to the store, didn't I?"

"Yes," she admitted.

"And I'm going to fix supper before I go to work. That's helping."

"I know, Alma, and I appreciate it." His

mother's voice softened. "I knew I could count on you. You and Pap always stick by me."

"I'm not putting in no window," Pap said. "Last time I used a saw I was fifteen years old and I done *that*." Alfie knew he was holding up the finger with the missing tip.

"*I'll* saw the hole, Pap," his mom said soothingly. "All you have to do is go over to the Wilkinses and get the window. It's been stored in the garage for five years so it's bound to need a washing. Maybe you can borrow their hose." She broke off and raised her voice. Alfie knew her face was turned to the ceiling. He knew her expression. "Alfie, will you come down out of that attic?"

He did not answer.

"Alfie, you come down this minute or I'm coming up after you."

He remained silent, staring at the trap door.

"Alfie!" It was a command now. "Come down this minute!"

Slowly he turned and eased himself down onto his chair. He was trembling a little. He breathed deeply of the warm attic air and sighed.

Chapter Nine

Alfie was still sitting in the attic. His arms were stretched out across the table. His hands were flat on the worn plastic top. It was beginning to get dark.

Below, the family was in the kitchen, eating supper.

"Alfie, you hear me?" his mother had called just before they went in. "Supper's ready. It's on the table."

He had not answered.

"Alma fixed it and she's going to be real hurt if you don't come down. What'd you fix, Alma?"

"Liver."

"Won't be no additives in that," Pap mumbled.

"It's something real good, Alfie, something you like," his mother lied.

She had paused and then she had started thumping on the trap door with the handle of a

71

broom. It was something she used to do in anger when they were living in an apartment and the Nolans made too much noise upstairs. Alfie remembered how angry her face had looked when she did it.

She had given him three more loud thumps with the broom handle and then, abruptly, had given up. "You try, Pap," she said.

"Try what?" He sounded startled.

"Getting him down."

"Well, how am I going to get him down if you can't? You're his *mother*."

"You can force the door open, can't you? You do that and *I'll* get him down."

"He's got that door fastened somehow," Pap said in a worried voice. "I went up and pushed on it. Alma saw me. I didn't want to push too hard lest he was standing on it. I didn't want to topple him."

"Pap, get up there and force that door open. I don't care if you topple him from here to China. This has gone on long enough."

"Forcing a door ain't like it is in the movies," Pap warned. "Doors don't just spring open with one kick. I had to force a door in a New Orleans hotel one time and I know. Me and two men worked on that door the best part of fifteen minutes. Never did get it open. The bellhop finally had to go in through the transom. And that was a regu-

lar door in a *wall*. How am I going to force a door that's in the *ceiling*?"

"With your hard head!" Abruptly her tone changed. "Oh, I don't care what you force it with, Pap. Just get it open, please."

"Give him a count of three," Pap begged, playing for time. He had always believed, Alfie knew, that if you waited long enough, everything would turn out all right by itself. "Don't be too hasty" was his lifelong motto.

Alfie glanced over at the barricaded door. He could imagine Pap standing at the bottom of the ladder, his worn face turned up to the task ahead.

In a strained voice Pap said, "Alfie, this is Pap speaking. Your ma's going to give you a count of three, and if you come down, why, then everything'll be all right. We'll go in the kitchen like nothing happened and enjoy whatever it is Alma's cooked and not a word will be said about the attic or any locked doors. We'll—"

"Quit stalling," his mother said impatiently.

"Your ma's going to count now, Alfie. She'll give you till three, and if you don't come down, well, then she's going to make me force the door open. I don't want to. I'm seventy-eight years old, but she's going to make me. All right, Alfie, your ma's going to count. Go ahead, Lily, he's ready."

"One . . ." his mother began.

Alfie could imagine the two of them standing together at the foot of the ladder, both faces turned upward. In his mind they were as unimportant as ants.

Pap burst out with, "She's counting, Alfie."

"Two . . ."

Alfie turned his head. He stared at the end of the attic where the window would be if he let them come up and install it. The last of the afternoon sun slanted between the boards.

"Three!" There was a silence, and then his mother snapped, "I knew it wouldn't work. Now get up there and open that door."

"Alfie," Pap called, "she's making me come up the ladder, me who don't even like to get up on a chair to change a light bulb. Come on down, Alfie. For Pap."

There was a creaking noise below as Pap took the first rung of the ladder. "I'm coming," he said wearily. It sounded as sad as the beginning of an old spiritual. "I'm nothing but an old tired elephant anyway who's no more use to—"

"Pap, *please* don't start on the old-tired-elephant routine." His mother was all but screaming with frustration and anger. "I simply cannot stand it. Just get up there and get that door open!"

"Well, I can't go but one rung at a time. You want the door forced open so bad, *you* come up

and do it. I'm seventy-eight years old."

"All right, Pap, just get him down at your leisure," his mother said in a voice of forced calm. "Take all evening going up the ladder if you want. I'll serve you supper on the ladder. I'll bring your pipe and slippers to the ladder. Only *get him down!*"

Pap reached up with one hand and knocked at the trap door. "Alfie, you up there?"

"Pap, we *know* he's up there," his mom said. She was still trying to be patient. "We saw him go up there. If I wanted someone to knock politely at the door, I'd have sent for Amy Vanderbilt. Alma, get the crowbar. It's under the sink."

"I'm not having any part of this," Alma said in a quiet voice.

"Well, get out of my way then," his mother said.

"Your ma's gone for the crowbar," Pap said. His mouth was almost touching the side of the trap door. "She's going to make me pry it open, Alfie. You might as well come on down. Once I get that crowbar . . ."

Alfie glanced at the trap door. The door was an inch thick. It fit tight except for the hole at the side where the light cord went downstairs. Pap, weak as he was, would never work it open.

"Here, Pap," his mother said.

"I've got the crowbar," Pap said. "This is your last chance."

There was a silence while everyone waited, without hope, for a sound from the attic.

Pap sighed heavily. "Well, hold me steady," he said. "Somebody get a grip on my legs. If my feet slip off the rungs, I'm done for. An old elephant with a broke hip ain't—"

"Pap, I warned you!"

"—worth much." There were scratching noises at the side of the trap door. "It won't go in," Pap panted. "The door fits too tight."

"You aren't trying, Pap."

"Well, old arms is old arms."

"Pap!"

"It's true, and my arms always have trembled when I held them over my head for a long time. That's what kept me out of the army."

"Pap, you didn't get in the army because you cut your trigger finger off with a saw. Now get that door open."

There were more scratching noises at the side of the trap door, feeble sounds as Pap tried to work the crowbar into the wood. "This is hard wood," he complained. "Feels like mahogany." The sound of splintered wood crackled at the door. "There, well, I done *some* good."

"Three splinters, Pap. Wonderful!"

"I'm doing what I can. I feel weak, though, and it's not just my arms. Maybe if I had my supper . . ."

"All right!" His mother gave in with a shout.

"We'll eat supper." She paused and lifted her head. "You hear that, Alfie? We're going in to eat. You stay up there and starve."

"He's not going to starve," Pap said. "He's got crackers up there and peanut butter, Kool-Aid, a regular pantry. He could stay up there a month if he'd a mind to."

"Well, he's not going to stay up there a month. I guarantee that. I'm getting him down."

"How?" Pap lowered his voice, but Alfie could still hear him. "To tell you the truth, Lily, I got as much chance of forcing that door as I have of picking up a mule. They don't retire old people for nothing. If them people at the plant had thought I was strong enough to force a door . . . but they didn't. That's why they let me go."

"*One* of the reasons."

"Anyway, the truth is I'm too old to be forcing doors."

"All right then, I'll call the fire department." She started into the kitchen. "Junior Madison works there, and I went with him in high school. Firemen are used to chopping down doors."

And now the house was quiet. The family was eating supper in the kitchen, and here he was at the card table, sitting in the darkness, staring at the end of the room. He had not glanced up once at his cartoons. He couldn't.

There were some things in old folk tales and

myths, he remembered, that you *couldn't* look at. If you looked, you would be turned to stone or a pillar of salt.

He knew that if he looked up at his cartoons, if he looked at his drawings, pale ghosts of happier days, he would be struck in the same way. When the firemen broke into the attic, they would find him changed to stone or salt, face turned to the ceiling, eyes blank, mouth open a little.

"He was like that when we found him, Lily," Junior Madison would say. They'd stand around sadly, and then one of the firemen would try to comfort his mother. "One thing, ma'am, he'll make a real nice statue. Any park would be proud to have him."

Chapter Ten

"Your show is on," his mother called to Alfie. "The one about international cartoons." It was Alfie's favorite program, but his mother's voice had a flat, hopeless sound, as if she knew he would not come down.

He did not answer. He had not moved for hours. His face had a hard set look, like clay.

The only change at all in Alfie had come with his mother's threat of the firemen. The more he thought of that, the more trapped he felt. The security of being in his own attic, locked away from the world, had been broken.

Firemen *could* stream in from all directions, he had thought as the minutes ticked slowly past. They could chop their way through the roof, the eaves, ax down the door. He imagined them swarming into the attic, hale and hearty as hornets in their yellow slickers. This would be the kind of assign-

ment they would really enjoy, he thought. They could practice their techniques without any risk.

It was Alma who had saved him.

"Mom, you are not going to call the fire department," she had said as they came into the living room after supper. Alfie could hear their voices much clearer up here than he had heard them below. Maybe sound rose like heat. "I mean what I'm saying, Mom," Alma said sternly. "Alfie has got to come down by himself. It's important."

"What do you know about it? You've never locked yourself up in the attic. You and Bubba had too much sense for that."

"No, I've never locked myself in the attic, but there have been other things that I've had to accept and work out for myself, and that's what Alfie's going to have to do."

There had been a pause. Alfie sagged a little in his chair. He knew there was no way he could work this out, alone or with the firemen's help. He could never come down the ladder into the harsh light of the living room, no matter what happened. It was impossible. He had gone into the woods like Hansel, turned, and the breadcrumbs were missing. There was no way back.

Maybe when he was very old, he thought, eighty or ninety, when there was nothing left of the boy he had been, maybe then he could come down. He

would be an old man, straggly beard, long gray hair, as thin as a skeleton, bent with arthritis and malnutrition. He would lift the trap door at last, trembling with effort, shaking in every limb, and slowly climb down the ladder.

There, in the faded living room, he would discover that his family—Mom, Alma, and Pap—had moved away years ago. A new family lived in the house now, a family who hadn't even known he was up there. He would stand bewildered and lost, blinking in the light, as frightened and confused at seeing the strangers as they were at seeing him.

Below, his mother said to Alma, "Yes, but he could be dead up there, Alma, or unconscious. That's why I wanted to call the firemen."

"He's not dead."

"Well, sulking then. That's just as bad."

"Look, I've got to go to work—I'm late as it is, but you are *not* to call the fire department. I mean that, Mom."

"The only reason I'm not calling them," she said, "if you want the truth, is because I do not want Junior Madison, who I went with in high school, to know I have a son who goes around locking himself in attics!" She slammed something down on the television. "The last time I saw Junior Madison was at the Morgantown-Fairmont football game which Bubba *won*, and Junior Madison told me he knew

81

how proud I must be of Bubba because his son had bad ankles and couldn't even run across the family room."

Alfie could hear the music of the international cartoon. His mother called, "Alfie, this cartoon from Yugoslavia is real interesting. It's about cities that keep building until they turn into atomic explosions."

"I don't know why they make cartoons like that," Pap complained. "Atom bombs ain't funny."

"It's not supposed to be funny. If you'd listened to what the woman said—"

"Well, *cartoons* is supposed to be funny." He got up from his chair. It creaked as he rose. "I'm going out back and see what the Governor's up to."

"He's gone to Pittsburgh, Pap. Don't you remember?"

"Oh, yeah." He sat again, heavily.

"You've started over there four times. I thought *old elephants* never forgot."

"Well, old brains ain't like new ones."

Alfie heard the music swell. He thought the city must be exploding in the cartoon now, spreading crayon radiation over the land.

"Hey, Miss-es Ma-son!"

Alfie lifted his head. It was one of the Finley twins calling his mother from the sidewalk. He recognized the high nasal twang.

"Hey, Miss-es Ma-son! We hear Alfie's in the at-tic!"

Alfie stretched his arms out on the table as if he were trying to reach the eaves.

"Is Al-fie in the at-tic?"

Somehow they made it rhyme. Alfie closed his eyes. He imagined himself as part of a jump-rope rhyme. Years from now thin-legged girls would be reciting his saga as they jumped.

"Al-fie's in the at-tic
Doing his car-toons."

"Miss-es Ma-son! Is Alfie being pun-ished?" Both twins were calling now in perfect unison. "Is Al-fie being pun-ished?"

The Finley twins had always had a special sense for trouble in the neighborhood. They never missed an ambulance or a police car. They sensed when and where a fight was going to break out, and they knew when a child was going to be punished. They would be leaping up at the window, like dogs after a bone, in time to see the first blow.

"What'd he do, Miss-es Ma-son? What'd Al-fie do?"

Alfie heard the front door thrust open. It banged against the porch wall. "Get away from here!" his mother shouted. "Get away from here before I turn the hose on you."

"But, Miss-es Ma-son," they persisted. They inched closer to the steps. They wanted to be gossip columnists when they grew up. "But, Miss-es Mason, *why* is Al-fie in the at-tic?"

"Scat!"

"What'd he—"

"Scat! Shoo! Get away from here!"

There was a clanging noise. His mother must have thrown something at them, possibly the framed picture of himself that sat on the TV.

Alfie's head sagged. He knew his mother must be very ashamed of him, and yet he didn't understand it exactly. She had not been embarrassed at all when Bubba had been arrested after the football game riot. She had told that over and over, to anyone who would listen. And the time Bubba stole a car to drive the cheerleaders to a game in Clarksburg—she had told that next morning in the grocery store. And Bubba's running into the police car and losing his job—she would make a good story out of that one day too, Alfie thought.

"Miss-es Ma-son!" voices called from the porch.

"Ignore them," Pap said.

"I *knew* Wanda Wilkins would spread it all over town about Alfie. I should never have . . ."

Alfie could hear his mother's voice fade as she went into the kitchen. She drew a pot of water. She crossed the living room, opened the door, and flung the water outside.

Alfie heard the splat, the two screams. The Finley twins must have taken a direct hit.

"We're telling our mom," one of the twins threatened as they retreated. "Miss-es Ma-son, we're telling Mom."

"And also tell *Mom* you were up on my porch trying to look in my door. Tell her *Miss-es Ma-son's* going to call the cops the next time you come poking around here!"

She sat down on the sofa. Immediately she got up. The springs creaked. She turned off the television. "Oh, I'm going to bed. I've had all I can stand for one day."

Alfie laid his head on his arms. The house was quiet now and he missed the noise. The sound of the television was a natural sound of the house, like the heater in winter or the wind from the north blowing through the eaves.

He lifted his head. Suddenly he actually felt like a statue. Maybe, he thought, he had turned to stone, even though he hadn't looked up at his cartoons. He felt like stone.

He imagined himself in a park, high on a pedestal, far above the world. No matter what happened around him he would remain unmoving at his table, hands folded. Pigeons would flap around his head, light on his shoulders. Children would throw stones at them, hitting him. The statue would remain perfect. Muggings would take place

85

in his shadow. Babies would teeter, fall, and cry. Girls would play games of tag around him. Only at night, like this, when the world got quiet, would the statue begin to soften. He closed his eyes. He became stone again.

Chapter Eleven

"Hey, Alfie!"

Alfie's eyes snapped open. He blinked. He lifted his head, turtlelike, and looked around the dusky attic. It was morning and there was no sunlight. The attic was as empty and cheerless as a stage waiting for props.

"Alfie, you ready for school?" Tree called. Alfie knew he was outside, standing at the edge of the steps. *"Hey, Alfie!"* he called again, louder.

Alfie waited with his hands folded on the table as if he were holding a small bunch of invisible flowers.

"Tree, would you come in the house a minute, please," Alfie's mother said at the front door. She had just gotten out of bed, and Alfie knew she would be standing in the doorway, clutching her peacock-blue bathrobe around her.

"Isn't Alfie ready for school?" Tree asked anx-

iously. "I can't be late again, Mrs. Mason, because I've already been late nine times, and if you're late ten times you have to write a composition."

"Just step inside for a second, Tree."

"Compositions aren't my thing." He entered, feet dragging. He looked around the living room. "Where *is* Alfie? He's not still in bed, is he? Look, Mrs. Mason, if he's still in bed—"

"Tree, Alfie's up in the attic," his mother said in a serious voice, "and I want you to help me get him down."

"*Where* is he?'

"In the attic."

Alfie could imagine his mother pointing up to the trap door, holding her bathrobe closed with one hand. He could see Tree's face lifted, puzzled, looking at the square door.

"He went up yesterday," his mother explained, "and he won't come down."

There was a pause. Then Tree said in an awed voice, "That's weird, Mrs. Mason."

Alfie recognized that as one of Tree's greatest insults. "He's weird, Alfie, sang a solo in the Christmas pageant. Oh, holeeeeeee night!" Or, "She's really weird, Alfie, toe-dances." Or, "Yeah, but somebody told me he plays the fife. He's *weird*, Alfie."

And now he, Alfie, had joined the group. Draw-

ing cartoons was bad enough, he thought, but locking himself in the attic really clinched it. "He's weird," Tree would tell everyone, "locked himself in the attic."

"Well, you know how he is, Tree," his mother said. "He just does things without thinking. Anyway, I thought maybe if you called to him, he'd come down and you could walk to school together."

"Well, I don't know. I could try." Tree cleared his throat. "Alfie, you want to walk to school with me?" He waited, then said in a lower voice, "I don't think he wants to, Mrs. Mason."

"Call again . . . please."

"Alfie, you going to school?" He paused, and then his voice began to pick up speed with his enthusiasm. "Listen, the reason I came by this morning is because Lizabeth and me are having a kind of war—it's not going to be anything violent, Mrs. Mason," he added quickly, "it's just going to be one of those boys against the girls things—like *Challenge of the Sexes* on television. Anyway, Alfie, we worked it out last night. It's going to be five different contests. And it's you against Zeenie in—get this!—bowling! And Zeenie's lousy too, Alfie. Half the time her ball never even gets to the pins. I mean, if it goes all the way down there, she's *proud*. Gutter balls are her specialty."

Tree swallowed, almost choking on his enthusi-

asm. "And, Alfie, here's the really good news. It's me against Lizabeth in *basketball*. I still can't believe she agreed. I mean, free throws are my specialty, Alfie. Everybody knows that. I can do them blindfolded, but she said, 'All right, fine with me,' and so we each get ten shots from the free-throw line— she takes one and I take one—or rather she *tries* to take one, right, Alfie?

"And then—more good news—it's Willie against Beth Ann in a race. He looks slow because he's fat, right, but you and me know he is *fast*. Remember when he stole my adenoids? Remember the doctor put them in a little jar for me and we chased him for seven blocks? Anyway, you got to come down. We need to make plans. And, Alfie, if I'm late to school one more time I have to write a composition!"

There was silence. In the attic Alfie could imagine Tree and his mother with their faces turned up to the trap door. There were sounds as Tree climbed up the ladder. He slapped his hand against the trap door. "Alfie, hey, come on down. This sex challenge is going to be one of the biggest things Morgantown's ever seen. We may get on TV!"

Alfie's mother let her breath out in one long sigh. "He's not coming, Tree."

"But he's *got* to. He's got to be in the challenge, Mrs. Mason. I already promised Zeenie he'd bowl

her." He raised his voice. "Alfie, I *promised* Zeenie. She won't bowl anybody but you!" He went up another rung on the ladder and lowered his voice. "Look, if you're mad about what I said yesterday, forget it. That's over with. I didn't mean it. This is too important for us to stay mad. This is *war!*"

There was another long silence while Tree realized slowly that Alfie was not going to come down. "Mrs. Mason, are you sure he can hear me up there?" he asked.

"He can hear you."

"But then why doesn't he come down? This is important."

"I know, Tree."

"We've got to make plans."

"I know." Her voice had a cold, ringing sound. "Alfie has upset a lot of plans."

In the attic Alfie shivered.

"Well, when he comes down, Mrs. Mason," Tree went on, "tell him about the war—he may not have heard all the details through the ceiling. And tell him to come on to school. We can't put this war off. We're *up* for it, you know, Mrs. Mason? We don't want to lose our momentum. Tell him I'm going against Lizabeth after school today—three o'clock in the gym. I know he'll want to be there for that. Did you hear me, Alfie? It's me against Lizabeth at three o'clock. And tomorrow, Alfie, it's you against

Zeenie. Now she's lousy, Alfie, but she's also the niece of the man who runs the bowling alley—Red Cassini is her uncle, Alfie, and he'll probably get some pro to coach her. Alfie, are you listening?" Tree stepped down from the ladder and started for the door. "Is that clock right, Mrs. Mason?"

"I think so, Tree."

"Then I'm late." His voice sank.

The door slammed, and Tree ran down the sidewalk toward school. Alfie heard his footsteps fade in the distance.

Alfie's mother went into the kitchen, plugged in the coffee pot, and sank down into one of the chairs. In a few minutes the scent of coffee reached Alfie in the attic. He glanced over at his own supply of food. He looked away. He wasn't hungry. Hunger seemed now to be one of those things he would never feel again. Like thirst. Or sorrow. Or happiness. He just didn't think he would feel anything again ever.

A raindrop fell on the roof. It made a loud sound as if the roof material were stretched, drum-tight, over the rafters. Alfie had never been in the attic when it rained. He put his head down on his arms.

The rain began to come down hard now, splattering against the roof in waves. It was a rhythmic thing, Alfie thought, like the ocean he had never seen. He closed his eyes and drifted back to sleep.

Chapter Twelve

"Alfie, do you hear me? This is Pap speaking." Pap's voice sounded as clear and pronounced as a radio announcer's.

Alfie lifted his head. The rain had slackened and was now a steady drumming on the roof. It gave Alfie a drowsy feeling. His eyelids drooped.

"Alfie?"

His eyes opened.

"Alfie, your ma's gone over to the Wilkinses' to use the telephone. She's calling to tell Bubba and Maureen to come on over as soon as they can get their things together. She's not letting on that you've locked yourself in the attic. She's telling them the attic is all fixed up like something out of a picture."

Pap pulled his chair closer to the trap door. Alfie could hear the chair legs scraping on the floor. Pap sat down heavily. He sighed, scratched

his chin. Alfie could hear his whiskers bristle.

"There's something I want to say before she gets back," Pap went on. "Now, Alfie, I don't want Bubba and Maureen staying here any more than you do. I wish *I* could lock myself somewheres. I'd do it if I thought it would do any good. Only it wouldn't. There's not much an old man can do to get noticed without them sending him to the asylum."

Pap cleared his throat and leaned back in his chair. Alfie knew Pap was looking up at the trap door now. He could hear the back cushion creak.

Alfie opened his eyes wide, trying to stay awake. He didn't know why he was so sleepy. It was mid-morning—he knew that from the television programs—and yet he felt as tired as if it were midnight. Maybe it was because of the bad dreams, he thought. All night long he had had nightmares in which cars crashed together and the ceiling cracked like a jigsaw puzzle and fell on him.

"So here's what I was thinking, Alfie," Pap said, his voice rising with his enthusiasm. "I was thinking maybe you and me and Bubba could get the junk-yard back. Harvey Sweet's let it run down. I was out there the other day—took the bus to the end of the line and then walked five miles just to see how things was—I miss that place, Alfie—and things was bad. Sweet hadn't got a new wreck in three months.

And the crown—remember the hubcap crown your dad made? Wreck King of West Virginia? Well, it's gone—blew down in the wind, Sweet said—and the whole place is looking run-down. I got a catch in my throat when I saw it."

He shifted in his chair. Then Alfie heard him get to his feet and begin lumbering around the living room like a bear just learning to walk erect. Alfie remembered that last day when the junkyard was being sold. Pap had walked among the ruined cars like a dazed, defeated general.

"Things could be the way they used to be, Alfie, when your dad was alive. You remember them days?"

In the attic Alfie looked down at his empty hands. Slowly he closed them into fists.

Below, Pap had gotten to the wall. Alfie heard his footsteps stop, then begin again as he returned. Alfie imagined him touching pieces of furniture as he had long ago touched fenders and windshields. "We had someplace to go then, something to do. Remember how we used to sit out there on a summer evening? People would come shopping for parts after supper, remember? That was our busiest time. And I'd sit there on an upturned Coke carton, greeting people, and you—you was as good at tracking down car parts as your dad. And when you got tired you'd take a rest in an old blue Dodge

sedan you was fond of. You *got* to remember the Dodge, Alfie!" He sighed.

"Well, Alfie," he went on, "it could be like that again. I know it could." Pap stopped walking, and Alfie heard the ladder creak as Pap leaned against it. "I know how you feel up there, Alfie. I have give up a time or two myself. I think about the government rotting away like an apple and senators using our money for trips to China—did I tell you, Alfie, *twenty-seven* senators is going to London, England, to pick up a copy of the Magna Carta? Which they could *mail*, Alfie! And you know who is paying them twenty-seven senators' way, don't you? You and me!" He snorted with disgust. "I think about things like that and about us giving money to countries that hates us and arms to countries that wants to shoot at us. Well, it makes me want to go somewheres too. Stick my head in the sand. Lock myself in a closet. Get where I can't hear no more." His voice lowered. "Only if we had the junkyard again, Alfie, well, it would make up for everything. Come on down and we'll talk about it. I got a little money saved up—don't tell your ma. It's not much, but we could use it for a down payment, get a loan for the rest. And Bubba—well, if he's good at anything, it's wrecking cars, and between the three of us—"

Pap broke off. "Your ma's coming back. She

looks mad too. Come on down, Alfie. No need to rile her any more."

Alfie could hear his mother running up the walk, taking the steps. She came in the door, shaking water off her raincoat. "It's pouring, Pap," she said, "and I couldn't get anything but a busy signal. Twenty times I dialed. You'd think they'd stay off the line when they knew I was going to call."

"Maybe they'd took it off the hook. A busy signal don't always mean busy."

She ignored him. "Maureen stays on the phone all the time. I suppose we'll have to have one installed to keep her happy. Is Alfie down yet?"

"No."

"It figures. When one thing goes wrong, everything goes wrong." She looked up at the ceiling and yelled, "Did you hear that, Alfie? You are now just *one* of the things going wrong. You are one of the two thousand and ninety-nine things going wrong!"

"Alfie and me was just talking about starting up the junkyard again."

"Oh, Pap, you know that'll never happen."

"We could do it."

"Forget it."

"How can I forget it when every time I see a dented fender I get a pain over my heart?"

Alfie closed his eyes. The junkyard seemed so

long ago to him. He couldn't go back. It was as if someone had taken him by the hand and said, "Remember how much fun being five years old was? Let's go back to kindergarten and make flowers out of pipe cleaners and masks out of paper plates." You couldn't double back.

Alfie raised his head and looked at the end of the attic. Water was dripping through the eaves, and a puddle had formed on the floor. Around him were the sounds of other drips. Alfie did not look up, because he did not want to see his cartoons.

There was an old game he had played long ago with Alma. "Heavy, heavy, hangs over your head," she would say, and he would have to guess what the object was.

"Is it made of wood?"

"No."

"Is it made of metal?"

"No."

"Paper?"

"Yes."

"Is it—cartoons?"

Alfie let his head drop heavily on the plastic tabletop. His pencils in their glass jar trembled. Pointing up, they reminded him of what he could not forget.

Chapter Thirteen

Alfie heard the opening music of his mother's favorite soap opera, and he knew it was three o'clock. Tree would be going into the gym now. Maybe he was already there at the free-throw line, practicing. Alfie knew just how Tree would look, one foot slightly behind the other, one hand on either side of the ball. He would bounce the ball three times for luck. His eyes would be riveted on the basket. He would shoot. Elizabeth wouldn't have a chance.

Alfie sighed. For a moment he wished he were in the gym with them. If he could have gotten there without going down the ladder and walking through the living room, he would have done it.

If only, he thought, he could move from one attic to another, walking through tunnels over everyone's head, unseen, unheard. He would stroll to the game, listen to Tree beat Elizabeth, walk

home through the tunnel, sit down at his desk. He would never have to see anyone. That was the way he wanted his life to be—a series of attics.

He laid his head on the table. The rain had stopped, and everything seemed clearer, as if the rain had cleaned the air. Sun was slanting through the eaves.

He imagined that by now Tree was probably halfway through the shoot-out. The score was probably five to nothing, Tree's favor. The boys would be counting every time Tree's ball went in the basket. *"Five!" "Six!"*

Below all was quiet. His mother had been to the Wilkinses' twice to call Bubba and Maureen, but she had gotten a busy signal both times. Now she was watching her soap opera, sipping a cup of coffee. The program ended in a burst of music, and his mother turned the channel to a game show.

Suddenly he heard Tree's voice. "Mrs. Mason, can I see Alfie?"

"Tree, he's not down from the attic yet."

"Well, that's all right. I just want to tell him something."

"Be my guest."

Tree paused, cleared his throat. "Could I speak to him in private, Mrs. Mason?"

"I'm watching television, Tree," she said. "Oh, well, I can hear it in the kitchen, I guess."

She walked out of the room, and Alfie heard Tree climbing up the ladder. Tree reached up to the trap door with one hand. He drummed his fingers against the wood. "Alfie, can you hear me?"

Alfie didn't answer.

"Because, Alfie," Tree went on—he swallowed loudly—"Alfie, I got bad news."

Tree paused a moment to see if Alfie was going to answer. Then he cleared his throat. He said, "You're not going to believe this." He swallowed again as if forcing down a large and bitter pill. He moved up one rung on the ladder. "Lizabeth beat me."

The silence stretched out, long and painful.

"I just don't know how it happened," Tree went on in a rush, "because I was really up for it, you know? That's supposed to count for a lot in sports—being psyched up."

He sighed. "Here's the way it was, Alfie. I came into the gym, all psyched up, and there were a lot of people there. It was packed. It had gotten all over school about our war—even Mrs. Steinhart was there—and I felt real good, Alfie; that's what makes it so unbelievable. If I'd been nervous and uptight—if I'd had a virus—but I never felt so good. It was like the time I fought Richie Davis, remember?"

There was a pause while he got into a better

position on the ladder. "Anyway, we got out on the floor, Lizabeth and me, and I clowned around a little—you know me, and everybody was laughing, and in the middle of all this Lizabeth goes up to the free-throw line and without any warning—I mean, she doesn't even bounce the ball for luck—she *flings* the ball at the basket, *flings* it, Alfie. It's the worst-looking thing you ever saw. It's like she's throwing a Frisbee, and it goes right in. All the girls go, *'One!'* Then they start yelling and clapping. Naturally all the boys are booing.

"Now I step up. I bounce the ball three times and I feel good, Alfie. I'm ready. I throw, and Alfie," he sighed, "I miss."

There was another pause while Tree got the strength to continue. "I don't know how it happened, Alfie. It was *my* shot. I did everything right, and—"

He broke off as Alfie's mother came in from the kitchen. She said, "Oh, I'm sorry, Tree. I thought you were through."

"No, I'm just getting started."

"Who won on *Match Game?* The water was running and I didn't hear."

"I didn't hear either, Mrs. Mason."

"Well, don't fall off that ladder."

"It wouldn't matter if I did," Tree said. He waited until she went back into the kitchen. Then

he said, "So now it's one to nothing, favor of her. Only, Alfie, I'm still not worried, because I know she just had a real lucky break. She could fling that ball a thousand more times and she'd be lucky to even hit the backboard.

"Now the principal comes in—*Mr. Harrington,* Alfie! I haven't seen Mr. Harrington since I cheated on those history dates. Mr. Harrington is like Howard Hughes, Alfie, he never comes out, and here he is strolling in to see me beat Lizabeth! It's the biggest thing our school has ever had!

"I figure I got it made now. I always do good under pressure, and Lizabeth will fall apart— remember when she had to sing that solo in the pageant, started too soon, and threw the whole chorus off? She steps up to the free-throw line, flings the ball—you won't believe how she does this—get her to show you when you come down— and the ball goes in.

" *'Two!'* yell all the girls.

"Now I *am* worried. Sure, free throws are my thing, but even Wilt Chamberlain can have a bad day. I bounce the ball three times, throw, and, Alfie, it goes in. I never saw a sweeter sight in my life. The boys go crazy. Everybody's yelling but the girls, and they're booing. It really made me feel good.

"Lizabeth comes up now. She flings and—I

knew it would happen sooner or later—she misses.

"I come up. I bounce three times, throw, right through the old hoop.

"Now the score is two to two, a tie which I figure I'm about to break. I can't wait till my time. I'm hot now. She gets up there, throws, misses. I get up there and I'm too eager, Alfie. I forget to bounce three times for luck. I miss. The score is still two to two.

"She gets up, flings, hits. The score is now *three* to two, her favor.

"I get up there, miss.

"She gets up there, flings and—real bad news— she hits. The girls go *'Four!'* real loud, Alfie. I felt like crying because, Alfie, now I'm down by two. I'm good, but being down by two is bound to affect my performance. I've never been known as a catch-up player. My way is to get in front and stay in front. You can't lose that way, and now I'm down by two!

"I get up, throw a bad ball, but it goes in anyway. Four to three. The boys are yelling so loud now I can't even hear myself think. They figure I'm closing the gap.

"She shoots, misses.

"I shoot, miss.

"She shoots, scores.

"I shoot, score.

"Now it's five to four, Alfie, and we each have

one more ball. If she hits, I'm done for. It's all over. She gets up there and I'm praying, Alfie. Every boy in the gym is praying. It gets real quiet. There's not a sound. She flings. She misses! Now I got a chance. I'm still alive. I figure I'll score and we'll go into sudden-death overtime. I can't wait. Sudden death is my thing. I get up to the line, bounce three times, throw, and, Alfie, it's the most beautiful throw I ever made in my life. It goes right for the basket. It rolls around the rim like it's going in— you know how golf balls do—it rolls around the rim like it's going in and then, Alfie—you won't believe this—it pops out! Alfie, it *pops out*!

"I just stood there and, Alfie, my mind went blank. It's a merciful thing that happens sometimes to people who've been in accidents and stuff, their minds just go blank, and that's what happened to me. I mean, I *must* have walked out of school and I *must* have walked to your house because here I am. But I don't remember one single thing from the time that ball popped out of the hoop until I climbed this ladder."

"Oh, Tree, are you *still* here?" Alfie's mother said, coming into the room again.

"I was just getting ready to leave, Mrs. Mason."

"Well, don't go on my account. My shows are over. Anyway, I've got to go next door and make a call."

"I was through."

Alfie's mother paused at the door. "Don't tell me *you've* got troubles too, Tree."

"Yes," he answered.

Her voice got louder to reach Alfie. "Too bad you don't have an attic to lock yourself in."

"Yes."

"That's the trouble with this world," she snapped. "There aren't enough attics to go around."

"You can say that again, Mrs. Mason."

Tree climbed slowly down the ladder, crossed the room, and left. The screen door slammed shut behind him.

Chapter Fourteen

Alfie sat in the attic, hands folded in front of him. He was tired—no, *weary* was the word for how he felt. His English teacher was always urging the class to find just the right word for their feelings, and now he had found it. He was weary. He had to make an effort to hold his eyes open.

Since Tree had gone, the house had been quiet. Pap was probably outside reading yesterday's newspaper, Alfie thought, looking for things to blame on the president. His mother had not returned from borrowing the Wilkinses' telephone.

The sunlight showed the dust in the air. Alfie thought that this floor had never been swept, not since he'd lived here anyway. There was enough dust, Alfie imagined, to make a man, like in the Bible. Or a boy. A dust boy could be made and sent downstairs while he, Alfie, stayed in the attic forever. His family would notice the difference, but they would excuse it by saying, "Alfie has never

107

been the same since he locked himself in the attic."

He lowered his head to his arms. He closed his eyes. He remembered hearing that in seven years a person became entirely new. It was the first happy thought he'd had. Every cell was replaced. Maybe in seven years, pink and shiny and new, he could come down the ladder.

"Why, Alfie, you look marvelous. Come look at Alfie. He's brand new."

"Alfie, are you still up there?" Alma called from downstairs, breaking into his thoughts. "Are you all right?" He had not heard her come in. He lifted his head. It seemed heavy.

"Alfie, I was hoping you were going to be down," she called.

He did not answer.

"Because I've been thinking about you all day. In Typing I got my hands on the wrong keys and typed for two minutes without noticing."

Alfie heard her drop her books on the TV. "Listen, want me to fix you something hot to eat? I'll slip it up when nobody's looking, because I remember how cold I felt that time Mom took my money. I felt like I'd never get warm again. How does hot chocolate sound?"

Suddenly the front door slammed. "Pap, where are you?" It was Alfie's mother and she sounded upset. "Where's Pap?"

108

"He's out in the backyard," Alma said. "Is anything wrong?"

"Is anything wrong? Is anything *not* wrong?"

"What's happened?"

"Alma, I am so mad. I am furious! Do you know what Maureen's parents are doing?"

"No."

"They are now trying to get Bubba and Maureen to live with *them!*"

"I'm surprised they want them."

"Well, they probably didn't until they found out *I* did. I could never stand that eely little woman. I *knew* she'd pull something. I told her I had the attic all fixed up. I told her all the plans I had. Alma, I could hardly get a word in. It was like trying to talk to a parrot. *She* had Maureen's old room all fixed up. *She* had Maureen's dressing room for the baby. She! She! She! And Piggie—don't forget that awful husband of hers. *Piggie's* getting Bubba a job at Quaker State. Piggie's doing this. Piggie's doing that. I tell you I could have smacked her—it was a good thing all this was happening over the telephone or I would have."

"Did you talk to Bubba? What did he say about all this?"

"You think she'd let me talk to Bubba? To my own son? Oh, no! And I know he was there. I heard his voice in the background at one point

saying, 'I wish everybody would get off my back.'"

"Well, maybe it's the best thing, Mom."

"Best thing for who? Not me! Not me who just put a ten-dollar down payment on a double bed at Hill's."

"Mom—"

"I wish you could have heard the conversation, Alma. Everything I said, she turned it around. I mentioned, just mentioned, that I was going to replace the ladder, and as soon as I said the word *ladder*, she said, 'Oh, Maureen could *never* go up a ladder. Maureen's afraid of heights. Maureen once froze on the diving-board ladder at Marilla Pool, and four firemen had to get her down.'"

"Mom—"

"That did it for me. I said very sweetly, 'Only four firemen? I should think, considering Maureen's size, it would have taken at least *six*.' Then she said, not so sweetly, 'Maureen's size is none of your business.' And I said—I was really furious now—"

"Mom!" Alma interrupted.

She broke off. "Oh, where's Pap? I want to see Pap."

"He's probably out back."

"Pap, I've been had!" she called. She stopped suddenly in the doorway to the kitchen. She said, "Although I realize I cannot expect sympathy from any of you. You have all been against me from the

start. You, Alma, have been very clear about your feelings. And Alfie up there in the attic—" She raised her voice without turning around. "Did you hear the news, Alfie? You can come down now. Maureen and Bubba aren't coming. Your precious attic is saved. You've won!"

Alfie did not move. His mother's words rang in his ears. He had won. This was victory. He remembered an old cartoon he had seen of a soldier slumped forward, tired beyond caring, worn down, eyes that had seen too much staring straight ahead at nothing. It seemed to Alfie the cartoon had been called "Victory." Alfie felt too flat and wound down to remember exactly.

Pap came lumbering into the house. His mother said, "Pap, did you hear the news?"

"Me and everybody else on the block."

"Oh, it is so infuriating! And that awful Piggie! During the whole conversation, Pap, he was babbling in the background. Tell her this. Tell her that. I could have wrung his neck." She raised her voice even louder. "Well, are you getting the message, Alfie? You can have your attic. You can go up there anytime you want to now."

"*If* he comes down."

"Pap!"

"Well, he can't go *up* if he don't come *down* first."

"If you start in now, I just cannot take it."

"It's the simple truth. He can't—"

"Well, I don't feel like hearing any simple truths now, if you don't mind. I want to hear some good old comforting lies." She raised her voice again. "Did you hear, Alfie? You have won."

"He heard you, Mom."

Alfie's shoulders sagged a little more. He hurt without being able to put his finger on what really was hurting. It was like the time Bubba had teased an old cat that lived with them. He had clamped a clothespin on its ear, and the cat had crouched down, cringing, but not shaking its head or scratching at its ear. It was as if it couldn't locate the hurt.

Suddenly Alfie wondered if Bubba had felt this way the first time he had done something wrong. He tried to remember the first of Bubba's deeds. Maybe it was the firecrackers he had set off in Cinema I.

Would this become a family joke too, Alfie wondered. Would his mother laugh and make this *funny*? "Did I ever tell you about the time Alfie locked himself in the attic? You'll die laughing at this."

Anguished, he shook his head from side to side. He remembered the time he had gone to the zoo with Pap and his mother. In a cage painted arctic blue, a polar bear had sat, shaking his head from

side to side, just as Alfie was doing. He had been the picture of despair.

At once Alfie had wanted to leave. He could feel the bear's hopeless anguish too clearly.

"Let's go to the monkey house," he had pleaded. Monkeys could always make him laugh. They chattered and picked each other's fleas and screeched at people as if the people were trying to get into their cages.

Also, he knew his mother loved the monkeys. She had had one as a pet when she was a girl. Pap had bought it from a gas station attendant. It had had seven outfits, and they were washed and ironed with the family's clothes. The monkey was dressed every day, and it had run away wearing a two-piece pink playsuit. Alfie's mother had never seen the monkey again, even though they ran ads in the newspaper for a month.

Whenever his mother visited the monkey house, she talked about what kind of outfits they'd look good in. "I'd get the gorilla a sailor suit, Alfie, pale blue with a straw hat to match."

But even in the monkey house, with his mother happily clothing the monkeys, he had remembered the silent, despairing polar bear.

"Alfie, are you coming down?" Alma asked from below.

He didn't answer. He didn't know. All his life it

had seemed to him that things would go on as they were. If he was happy, he would always be happy. When he hurt, he could never see relief. The way things were, that was the way they would always be. He could not see beyond this chair, this attic, this flat misery.

"Because you didn't *win*, Alfie. Mom was wrong. It didn't have anything to do with you really. Bubba and Maureen decided on their own to live with her parents. They didn't even know about you.

"*I* didn't win when I threw a fit and smashed my bank and almost had to be driven to the hospital. It was just something I did because I couldn't stand what had happened to me. But even if I had gotten my money back by doing what I did, I still wouldn't have won. And you didn't win either."

Alfie waited. He shut his eyes. He felt as if he were getting a cold. His eyes burned with tears.

"So don't feel like you've won," she said. "Did you hear me, Alfie? Don't feel like you've won!"

I don't, Alfie said, so softly the words didn't actually leave his mouth. He cleared his throat. He spoke for the first time in twenty-four hours. "I don't," he said.

Chapter Fifteen

"Well, come on down then," Alma called. "Supper's ready."

He kept sitting at his table in the attic. He felt swept away by emotion—like those people caught in the *Wizard of Oz* tornado, whirling past Dorothy's window, sitting normally in rocking chairs or pedaling bicycles, all the while being carried away. Alfie felt himself circling closer to something.

Suddenly a fly buzzed around his head. It lit on his ear. Alfie brushed it away. He felt irritated at the intrusion.

The fly must have been here all along, he thought, resting on a beam and had chosen this moment to fly down and irritate him. It was like the fly in a television studio that waits until an actor is on camera, in his most moving scene, and then comes down and buzzes around his made-up lips. He swatted the fly away again.

"Is Alfie coming down for supper?" his mother called from the kitchen. "Tell him it's Sloppy Joes."

"He's coming," Alma said.

"Well, if it's Sloppy Joes," Pap groaned, "I'm *going*. Them things is not fit for human consumption."

"Then they should be just right for *you*," his mother said.

Alfie leaned back in his chair. The fly had left as quickly as it had come. It had been strange, like a touch from a wand. He thought of those old stories where the fairy godmother waves her wand and in a shower of sparkles changes evil to good and ugliness to beauty. Only *his* fairy godmother, he thought, was old; her wand, weak. She had noticed him in trouble here in the attic and had waved her wand over him with all her strength, really wanting to change the whole world for him. But instead of magic sparkles, her wand had given off one tired fly. It had buzzed down, touched his ear, and been whisked back.

His fairy godmother was waiting above him now, holding her wand anxiously. To the fly she'd be saying, "Well, it's up to him now. We did our best."

Alfie let the air go out of his lungs in one long sigh. He remembered what was really waiting over his head. Slowly he turned his face to the ceiling.

He lifted one hand as if he were going to shield his eyes. Through his tears he saw his cartoons

They hung pale and still in the warm, dusty air. "Super Caterpillar." "Super Bird." The boy with the turned-in feet. The chicken. The children. The old man and woman with their car.

He rose from the table the way Pap got up from a chair, as if he weren't sure he would make it, as if he feared his bones were going to give way. He stood. He stepped back from the table, stumbling a little on the uneven boards.

Then slowly, as if he were picking fruit, he began to take down the cartoons. Scotch tape pulled off with a sigh. Thumbtacks gave. Paper tore. One by one the cartoons came off. The pile grew in his hand.

He pulled the last one, "Super Caterpillar," from the rafters and put it with the others. For some reason he felt a little easier, as if the clothespin had been taken from his ear without his knowing it. He rolled the cartoons up like an awkward diploma.

Holding them under one arm, he slid the board from the trap door. He opened it. He looked down into the room below. For a moment it looked wrong, like a negative. Black was white; white was black. Then everything got normal.

He started down the ladder. He could hear the

family in the kitchen. Pap was saying, "Don't nobody care what I want to eat anyway. You get old—it's like in the jungle—the old elephant can't reach the good leaves no more, and nobody'll pull them down for him."

"Pap, if you start in on the old-elephant routine now, I really will scream."

"All right, Pap," Alma said, "what do you want to eat? Tell me and I'll fix it for you."

"Anything I want?" he bargained.

"Yes."

"I want a souse meat pie."

"A souse meat pie?" his mother said. "Are you loony? Where's Alma going to get a hog's head?"

"I'll get one, Mom."

Alfie paused on the ladder. Suddenly he thought that maybe it was possible to make a cartoon even of this. The idea surprised him. He leaned his cheek against the wood. Not a cartoon of himself—he wasn't ready for that yet. He could do a comic strip about a *man* who had taken himself away from the world. He was better at drawing men anyway. In a balloon, he thought. Balloons were better than attics in a comic strip. He warmed to the idea.

In the first square a man would be suspended over the world in a balloon. He'd be saying, "Nobody can make me come down!"

In the second square he'd be saying, "*Nobody can make me come down!*"

In the third square he'd be saying, *"Nobody can make me come down!"*

In the last square he'd be saying, "But somebody could try."

Alfie smiled. He was glad there would still be cartoons. He climbed down the remaining rungs of the ladder. He stepped on the living room floor. He felt jarred for a moment, as if he had stepped on something unexpectedly hard. He put one hand on the ladder to steady himself.

He set his cartoons on the television. They unrolled, and he put Alma's books on top to hold them. He walked into the kitchen. "I'm down," he said.

BETSY BYARS was born in Charlotte, North Carolina, and graduated from Queens College.

The mother of four, Ms. Byars began writing books for children as her family was growing up. She is the author of nearly fifty books for children, including *The Summer of the Swans*, which received the 1971 Newbery Medal.